The Complete
Drawing Course

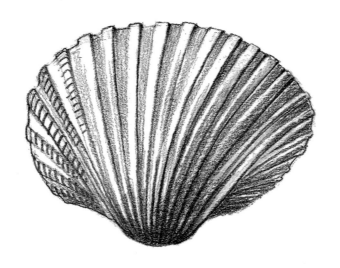

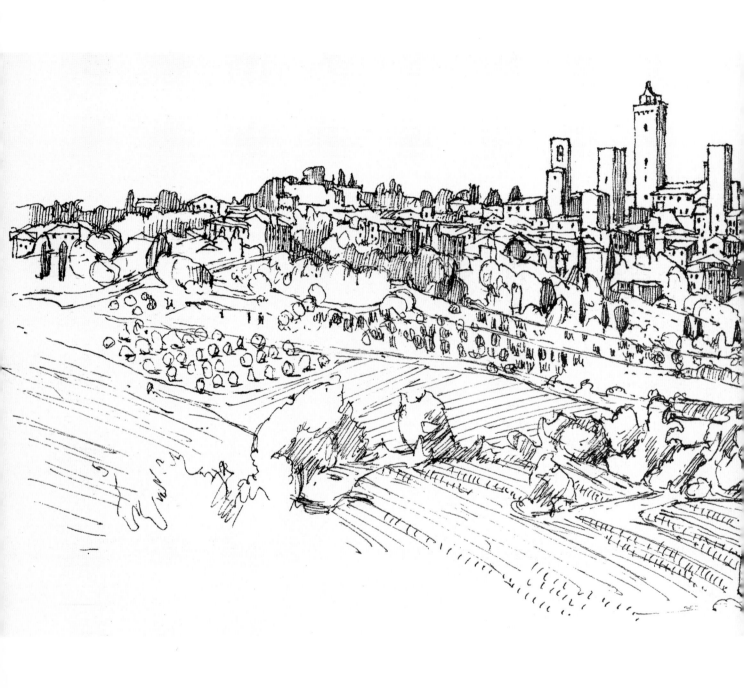

The Complete Drawing Course

Michael Woods

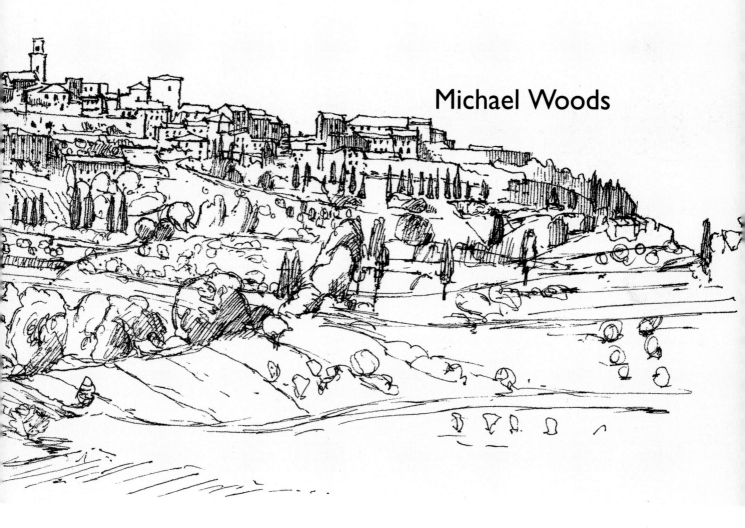

B.T. Batsford Ltd. London

Somerset County Library
Bridgewater, NJ 08807

First published 1995

© Michael Woods 1995

All rights reserved. No part of this publication may
be reproduced in any form or by any means,
without permission from the Publisher.

Typeset by Goodfellow & Egan Ltd, Cambridge

Printed and bound in Hong Kong

Published by
B.T. Batsford Ltd
4 Fitzhardinge Street
London W1H 0AH

A catalogue record for this book is available from
the British Library

ISBN 0 7134 7241 3

DEDICATION
To Geraldine and Jemima

ACKNOWLEDGEMENTS
I would like to thank Colin Heafield of
Daler-Rowney Ltd for his technical advice,
and my wife, Jacqueline, for all her help.

Contents

introduction

What is drawing? We start with a sheet of crisp, clean paper and then make marks all over it. What is this strange occupation? Why do others then stand and look at the result, shaking or nodding their heads? I must admit, it's a very rum job!

But drawing is about thought, desire, love and mood, as well as making marks on paper. When enough marks are gathered together, they might be called a picture, but the artist must think about these marks before making them. 'Desire' is important because I feel quite certain that we must want to draw — not just to think about it or talk about it or look at it, but actually to do it. 'Love' might be a rather over-dramatic way to describe the artist's relationship with his or her work; perhaps I should use the word 'selection'. We all have preferences. To feel enthusiastic about a particular place or object is vital if there is to be a spark in the resulting drawing. And what of 'mood'? Here I am not referring to that frequently used excuse 'I don't feel in the mood', but rather to the artist's sympathy with his subject, be it person, place or thing; a quality recognised. I find myself using the word 'smell' in this context. One cannot put a smell into a drawing, but the atmosphere of a place can be conjured up if the drawing is successful.

All this may make drawing sound lofty and out of reach, but it is not. It is a language, and can be learnt. The message it gives to

Rupert Street, London.
Pen and ink on paper

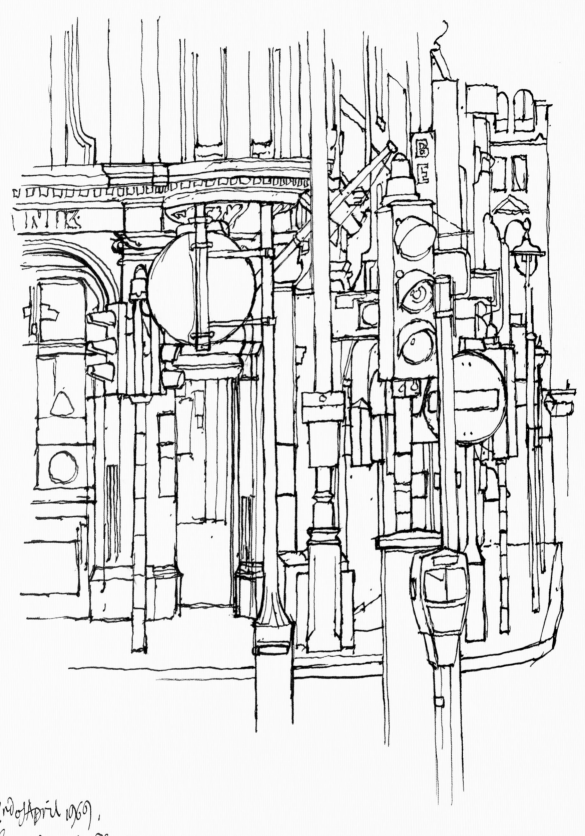

2nd of April 1969.
from Rupert Street
towards the Prince of Wales.

others may vary, but the possibilities are there for all. We must not be discouraged by the huge sums of money associated with the drawings and paintings of great masters. Instead, we must admire the skill of these artists, and feel the excitement of being able to try to draw for ourselves.

However, such excitement does not mean that a drawing will just happen. Progress can sometimes seem very slow, although at other times one can suddenly leap forward. The notion that you either can draw or you cannot is quite wrong. The desire to succeed will make you want to practise and, as time passes, understanding and awareness will grow as well. One cannot expect results without some sustained effort.

To draw seriously may require sympathy, or at least understanding, from your immediate family and friends. Very few people have any grasp of what it is to be an artist. Too frequently, the comment is made, 'Oh, I wish I could draw', or 'You *are* lucky', as if one is indulging in a never-ending summer holiday, achieving success with a few deft strokes. How relaxing! In some ways I do relax when working, but when not drawing or painting I am never relaxed. If I observe something that excites me, this will take priority over meals, other people, even time itself. It may seem selfish, but drawing has to be given time. If you are lucky those closest to you will understand.

Enrolling for a drawing class is an excellent way to progress, giving the student the opportunity to learn both from the tutor and from others on the course. A specific time is set aside when one can use the available facilities and concentrate; without this, improvement can be slow. Choosing when to start, what to draw, which materials to use, is all part of the learning process. In the following pages I shall explore the attitude that lies behind a successful drawing, and show how an understanding of the visual world, the formulae and symbols used in communication, is essential to every artist.

A great drawing seldom results from a painstaking copy of a photograph. In a particular context there may be merit in it, but it will often lead to an over-emphasis on the subject rather than on the fine balance between the means by which the subject is described and those aspects of the drawing that concern the artist. Drawing is about selection; it is like reading a headline in a newspaper or hearing a news bulletin on the radio. A drawing of a tree is not a tree, but some marks on a sheet of paper which may come to be understood to represent a tree. Whatever the quality of the result, a great sense of freedom can come from grasping the nature of what drawing is about. Understanding and control are not niggly, inhibiting things; they establish a foundation, which gives the opportunity for choice. We are lucky that art is now no longer bound by any one established style; however, freedom can be a mixed blessing when combined with inexperience and preconceived notions. For this reason, tuition is vital to progress.

It is important to examine why an error has come about,

otherwise it can all too easily happen again. Criticism of a drawing should be constructive; more often than not, it is more valuable for the next piece of work than for the one in progress. I often feel it is better to complete a drawing, whatever its imperfections, and to try to achieve a better result next time. Another important point to remember is that it is sometimes possible for a teacher to give too much advice, and if just one helpful remark is made at the right moment, much will be gained.

There is no absolute order when planning a drawing course. The logistics of setting things up, the availability of materials, the time of year, and other chance circumstances should all be taken into account. What is important is the variety of subjects covered, and the range of materials and methods used. Try to work through the following chapters in the suggested order if possible, but remember that it can be equally valuable to return to an individual subject. However, try not to leave out a task simply because you don't like it! Give it a chance and see what your opinions are afterwards.

To look at drawings in galleries and exhibitions will provide many answers as well as jolts for the less experienced artist. Frequently the technical method will be seen far more clearly than in any reproduction. I often dissuade students from smudging a drawing with a finger, yet I always remember the shock I had when I saw some Matisse portrait drawings, in which he had done just that – but, of course, brilliantly and with great selection.

Drawing presents endless possibilities for the artist – some frustrations, almost certainly, but a great deal of pleasure, too. With a lifetime to practise, there need be no retirement from drawing.

2B pencil on watercolour paper

Chapter One

materials

Any old pencil and the first piece of blank paper lying about – that's all that's needed! 'Oh, come on,' I can hear someone saying, 'there's a bit more to it than that.' Well, yes, I agree, but – and it's quite a big but – drawing is not in itself about special materials. They expand a range, they provide a versatility and knowledge of what's possible which can speed up the whole learning process, but the best range of materials on the market will not necessarily make a brilliant drawing.

Pencils

In my experience, most students, when given the choice of an implement with which to draw, are likely to choose a pencil – and what a marvellously versatile thing it is. *Pencillus* is Latin for brush, and the term is still used for a fine brush. It is not easy to distinguish where drawing ends and painting begins, especially as we speak of 'a sense of drawing' when considering paintings. The origins of the modern pencil can probably be traced back to the sixteenth century, when pure graphite was used, later refined by the addition of clay. The great range of pencils available today is the result of the careful selection of materials, which are ground very finely before being fired to the correct temperature, and encased in wood. Although pencils are usually graded, makes do vary, so select

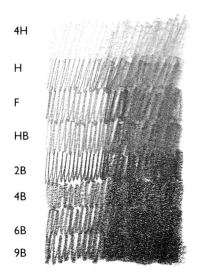

4H

H

F

HB

2B

4B

6B

9B

Marks produced by
a range of pencils

a brand that is readily available and that provides a wide range from which to make your choice. Starting at the hardest end of this range, we come to those pencils marked H. Of these, 6H is harder than 2H; this means that, when making a line, the point will remain sharp. It will deliver only a fine mark and, because little material is being deposited, this will be a pale grey. H is followed by F, then HB marks the turning point towards an end which will grind down more quickly but will deliver a thicker and darker line. A 6B pencil will be softer and make a darker line than a 2B. One of the most common errors made by beginners is to select too hard a pencil for drawing use. I recommend a 2B to gain experience, because it can be used to draw thin lines as well as rich solid darks.

If the point of a pencil is sharpened with a rotating sharpener, a fine even-width line will initially be achieved, but quite soon (and

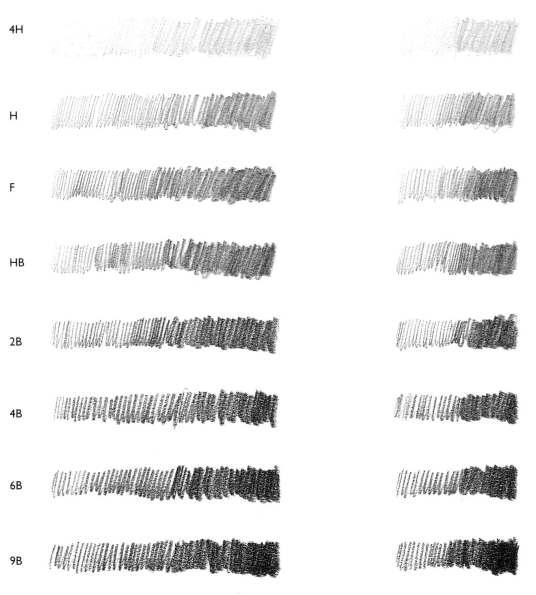

4H

H

F

HB

2B

4B

6B

9B

the softer the grade, the quicker this happens) the end will become blunt. I use only a craft knife for sharpening pencils so that they can be given a longer, blade-like end and a more chiselled tip. The wood should be cut well back so that the shoulder does not get in the way. Expect to have to resharpen your pencils quite frequently.

I have given only a brief account of the variety of pencils available. Their qualities will change, too, according to the paper with which they are teamed. The 'common' pencil produces a fine pale-grey line when hard, becoming coarser and darker when soft. The black tends to be rather grey. If the paper is solidly covered with a very firm application, the area of black will become quite shiny – in some circumstances not a pleasant quality. The manufacturer's labelling may describe sets of pencils as 'Artist' (sometimes a higher quality), 'Drawing' (possibly of average quality and for general use), 'Sketching' (the softer end of the range), and 'Graphic' (a range from H to 8 or 9B). The size of the rod can vary within the wooden case and this can have a marked effect on the lines and areas made. Some pencils have a broad rectangular rod encased in rectangular wood – this makes a strong 5 mm line.

Many pencil manufacturers also produce a range of coloured pencils. These tend to make a dry, creamy mark, and the blacks are particularly good, while the white is excellent when working on a darker paper.

Also available is the mechanical pencil, a metal or plastic construction which takes a rod of graphite for ejection by stages. Although these can be very useful to the artist, the versatility of the tip is limited by the metal support from which it protrudes, which makes sharpening a pencil to a chisel tip very difficult. It is also impossible to use the pencil at an angle low to the paper because the metal container gets in the way. In some cases they may wobble slightly. For these reasons I personally don't use them.

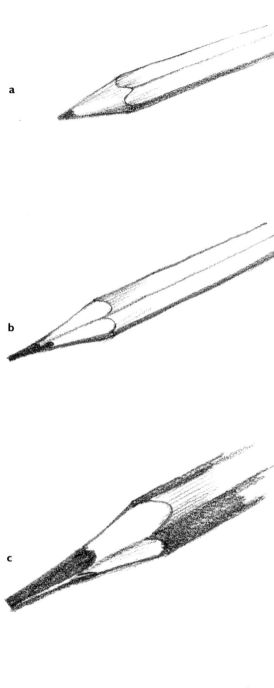

a Mechanically sharpened pencil

b The chisel shape of the tip

c A long, lean shape gives considerable versatility

d A poor tip left when too little wood is removed

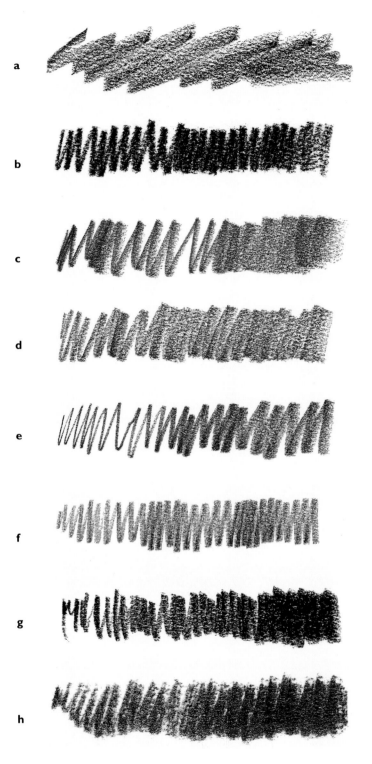
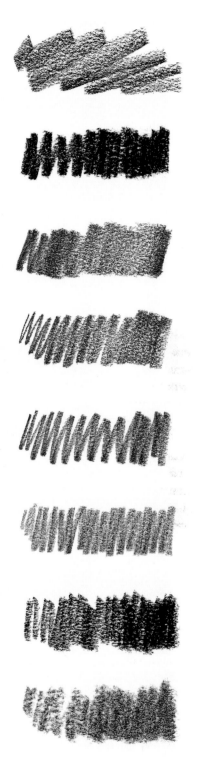

a Derwent Drawing (Rexel Cumberland)
b Swan (Carb-Othello)
c Conté 12 mm stick
d Faber 8 mm stick
e Progresso 2B (Bohemia Works, Czechoslovakia)
f Staedtler Noris
g Conté stick: 2B, black (65 mm long, 5 mm square)
h Charcoal. Thin willow stick

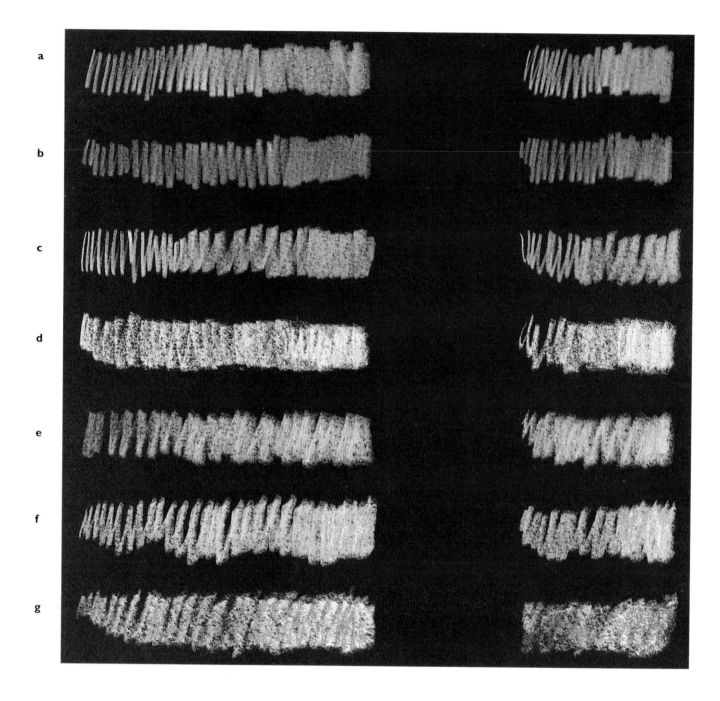

a Derwent Drawing, Chinese White (Rexel Cumberland)

b Conté white drawing

c Derwent Drawing (Rexel Cumberland, 6 mm wide)

d White conté stick (65 mm long, 5 mm square)

e White wax (Rowney)

f Oil pastel (Filia)

g White chalk

Two types of solid
sticks of graphite

Graphite

In many cases what goes into a wood-covered pencil can be purchased as a stick of material on its own. These graphite sticks are round, square or even faceted, and are considerably thicker than conventional pencils. They are less likely to break during use, therefore. Again, there is a considerable range and it is essential to experiment, but on the whole they are excellent when working on larger, bolder drawings. They do tend to be messy and, although there is nothing wrong with that, it can be difficult to keep the drawing clean. Your fingers almost certainly will not be.

Charcoal

Charcoal (also known as carbon) is a variation on the pencil. It feels much drier, and grates slightly when making a mark, but the quality of the black may be richer. One advantage in using it is that the solid build-up does not produce a shine. Real charcoal is quite different to the charcoal pencils that can be purchased, for the smaller sticks are actual twigs of willow, while larger sticks are formed from pieces of branch, prepared by burning under controlled conditions. Charcoal is a classic, simple drawing material, usually associated with larger, bold drawings. The range of tones possible is wide but subtle (see page 13).

Conté

Although conté is a brand name, it has become synonymous with creamy dry chalks, frequently square in section. It is hard to define the difference between chalks and pastels, but it is probably sufficient to say that chalks tend to be harder while pastels are softer. The white chalk used on a school blackboard is about midway between the two (see opposite). It is in white what charcoal is in black, and for this reason they make a happy duet, though there are some limitations in working them into one another.

Crayon

Wax crayons use a body of wax as a binding agent, and this tends only to mix with similar materials, although it does have the advantage of producing a water-repellent resist. Wax crayons can

a Black wax (Rowney)
b Oil pastel (Filia)

a

b

therefore be used with water-based washes. Oil pastels, like crayons, have an oily-waxy nature and can slide easily over the paper. Neither of these media is at all easy to remove.

Erasers

At the other end of the scale to crayons and oil pastels, graphite pencil can be erased most easily, although tests should always be made because of the difference in textures and particularly in surface strength between various papers. If a drawing instrument dents the paper surface then no amount of rubbing will remove it and the trough will blemish further work. Few people who start drawing are happy to begin without an eraser to hand. It is important to buy one of good quality, which probably means the most expensive. Choose a reputable manufacturer, and don't use one of the cheap varieties made for children, as these can spread rather than remove marks. In most cases, I cut my erasers diagonally in half to give a pointed end for delicate removal. The sort of eraser that is made from soft, pliable putty rubber has never been a favourite with me. Although, when clean, it can be dabbed on to remove excessive application, it collects some of the graphite that it removes and soon becomes sullied with suspect remains.

Pens

The pen is the most wonderful drawing instrument. It makes the eraser obsolete, for once a mark is there it's there for life. (Although it may be possible to scratch away a bit of the paper.) The goose-quill cut will hold a dark liquid, and what a line it produces – so subtle and varied in its thickness!

c

a A standard eraser
b Putty eraser used backwards and forwards
c Putty eraser used lightly to pat off an area

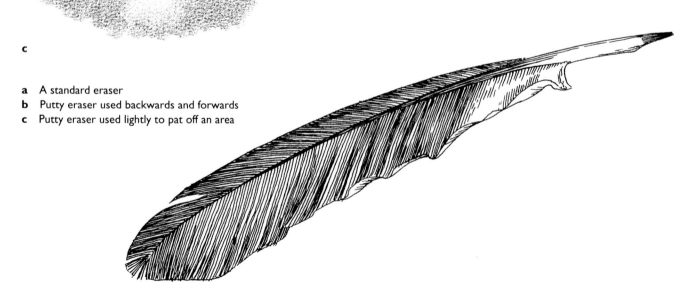

A quill pen made from a goose feather

After the goose quill came the metal nib, which is marvellously versatile. But beware! As a student I wanted to be a purist and I well remember walking around with a dip pen and glass ink bottles retrieved from old writing cases: the drawings gained but my jackets suffered!

Next came the fountain pen, containing its own ink, but although this worked well for writing, the nib tended to be insensitive and stiff as a drawing instrument. Recently, however, one manufacturer (Rotring) has produced a very acceptable pen designed for art use. It will accept both cartridges and a refillable reservoir, and is available with a range of nibs. The ink flow is superb – when drawing, there is nothing worse than a nib which will not flow. The Rotring pen does not replace the true dip nib, but it is first rate for field work where time is limited. However, no pen will work well without being cleaned from time to time, so remember to wash your pen thoroughly, allowing the water to work through the fine delivery channels. When the ink is back at full strength, check that it is flowing freely.

I shall say more about the qualities of drawn lines in later chapters, but here a technical comment is appropriate. When making a line or mark, it is important to use a versatile instrument

Marks made by a pen with a flexible nib

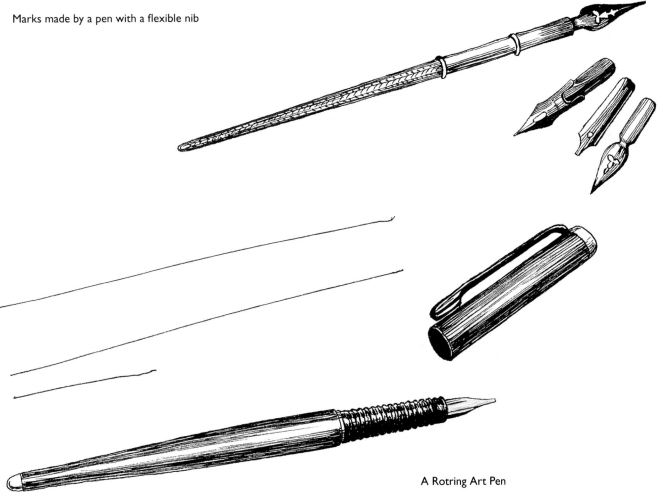

A Rotring Art Pen

that will produce, by the way it is shaped or handled, a line varying from the barely perceptible, delicate and thin, to a broad, rich, dark swipe. While pencils and chalks will change as they wear down, with marks being made in any direction, the pen is quite different. The nib structure stays exactly the same however often the pen is used. It delivers the ink onto the paper via the split down the centre of the tip. The greater the pressure, the greater the flow of ink as this split opens slightly. The tip will dictate the range of marks available from that particular nib. Most pens are happiest when being moved in a direction away from the tip, that is, being dragged. Few dip pens will tolerate being pushed – they will catch the surface and splatter ink. But the modern artist's fountain pen is surprisingly tolerant and will make marks in any direction. A nib having a broad chisel tip will be able to make a versatile line, thin when moved sideways and broad when dragged in the direction of the shaft. Chisel tips are used by calligraphers to make variations in the lines forming letters.

Lines made by:
a A metal nib dipped into ink. The ink runs out but the splayed tip continues a little further
b Rotring Art Pen – broad
c Rotring Art Pen – fine

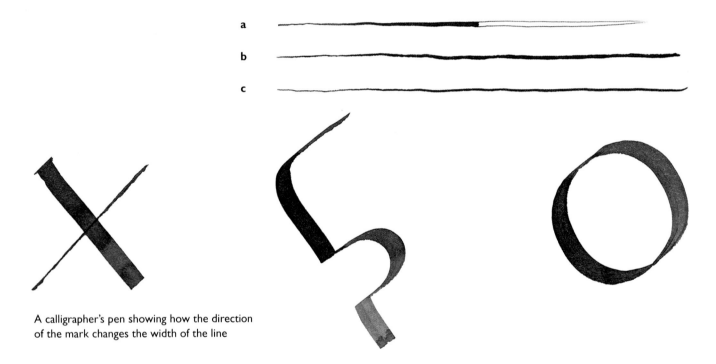

A calligrapher's pen showing how the direction of the mark changes the width of the line

Brushes

A brush will also create beautiful lines. Brushes are probably more suited to larger-scale work, and certainly come into their own when making a line or mark with a single stroke. The stroke might be long or short, but while it is being made the brush should not leave the surface. Whereas the pencil can touch and retouch, building up a line or patch, the brush is best used to make a mark in one confident action. It resembles the pen, in that the shape of the brush does not change; the movement given to it controls the mark that it

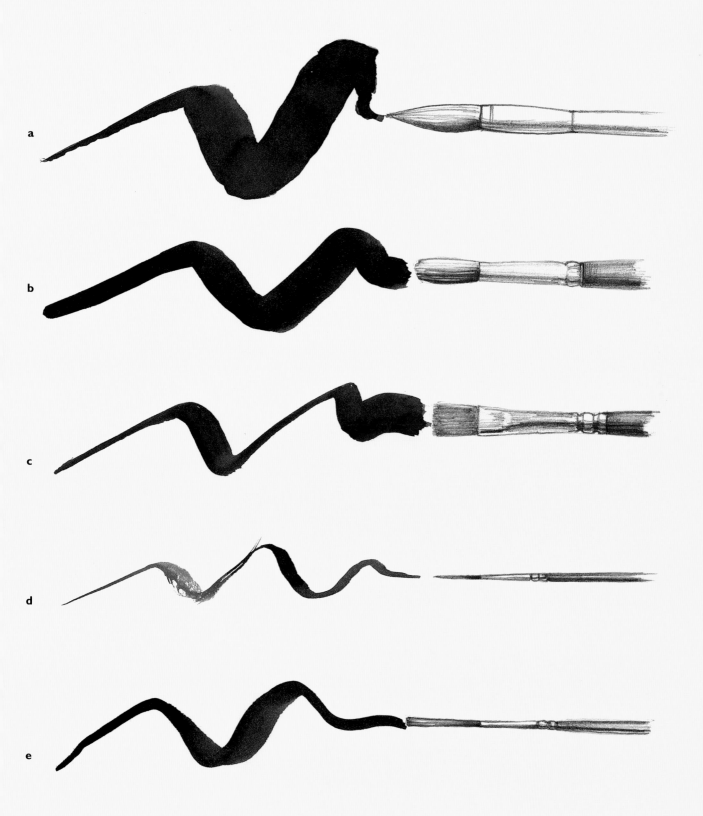

Brushes and their marks

a Chinese, having a bamboo and/or plastic shaft

b Round-ended watercolour – when new, these can look quite
pointed but when wet they may produce a blob

c Chisel/square-ended – works like a broad pen

d Fine line – produces sensitive squiggles

e Liner – the longer hairs will increase the ink capacity

makes. Thus the square-ended brush will make thinnish lines when dragged sideways, and chunky blocks when drawn down its width. Brushes with a long thin group of hairs will produce long thin lines, and the longer the hair the longer they will flow (for they carry more liquid) and the less any shaking of the hand will be visible on the paper. Unlike the nib on a pen, the hairs of soft brushes will bend as they touch the paper. For this reason the quality of the brush, the springiness or floppiness of the hairs, will only be appreciated when wet and under working conditions. To see a neat-ended brush in a shop can be very misleading, particularly as some have a weak glue applied to hold their hairs in place. Only when this has been dissolved will the working shape be truly revealed. This frequently applies to brushes with hairs set in bamboo handles. Other brushes may have a plastic sleeve protecting their end. Quite naturally, shops will be reluctant to let a purchaser try out brushes using ink or paint, and although water may be permitted, it does not have the same consistency. If a friend has a collection of brushes it may be possible to get advice and to try some, but in the end quite a lot depends on making your own decisions and trying to find types or makes which suit you.

Brushes do benefit from being kept clean. In most cases, soap and warm water will remove traces of past pigment, and when hairs have become bent while drying they can be restored, but care should be taken not to use very hot water, which can cause the hairs to fall out. Do not immerse the brushes in water with the hairs jammed at the bottom of a jar; rather tease out any pigment by working gently in the palm of the hand and between fingers and thumb. Rinse under running water and then reshape the hairs. Hairs can often become bent when placed in watercolour boxes or containers in which they move about. A brush folder, easily made from a firm fabric like canvas or leather, will hold the handles, while a stiffened back piece will protect the hairs. The flap should be long enough to fold over the tallest brush.

Badly distorted hairs rectified by soaking in warm water

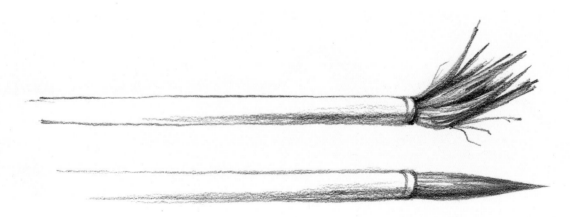

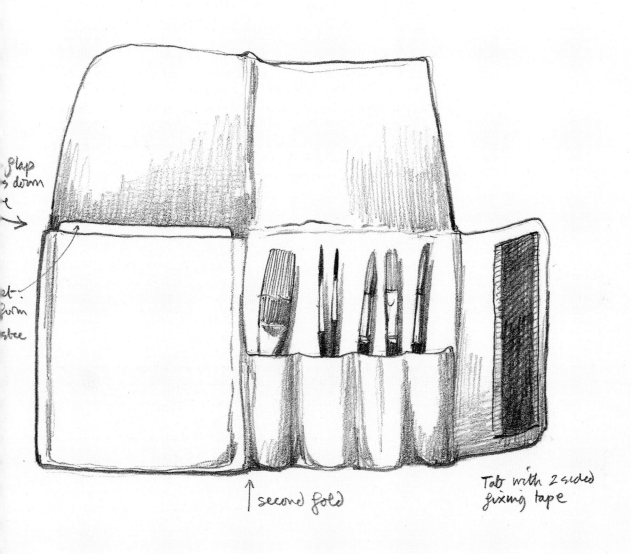

flap
s down
e

et.
form
stee

↑ second fold

Tab with 2 sided
fixing tape

A home-made brush pouch containing a group of brushes
with shortened handles – very useful for fieldwork

Inks

The term 'ink' is a wide one. Today's inks use very strong dyes.
Most of those made for writing are semi-transparent; so-called
'blacks' are hardly that. Drawing inks, on the other hand, can be
very dense and yet flow very well; they are water-soluble, which is
useful in some sorts of drawing. Ink terminology is often confusing,

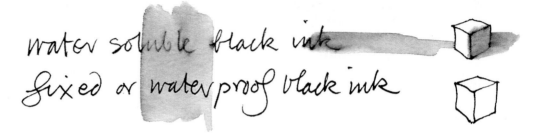

with 'permanent', 'light-fast' and 'fixed', 'water-soluble' and
'waterproof', 'pigmented' and 'transparent' all found on
containers. Permanent or light-fast is likely to mean that the ink
will not fade in sunlight. (It is most embarrassing to find that a
drawing has disappeared after two years!) Fixed or waterproof
probably means that, when dry, an overlaid wash of water will not
move the ink. This type of ink was formerly called 'Indian'. It can
be very dense and may not flow easily. Because it dries quickly, it
will often clog a pen and stiffen a brush. When using any specialist
pen do heed the manufacturer's advice on ink, for the tolerances of
such pens are so fine that they simply will not work with just any
liquid.

Stick ink is a block of pigment which may be ground in water
to the required density, and creates the most beautiful greys. A
similar effect can be achieved using thin water-based paint, but the
pigments have a tendency to settle out and the strength of the
colour can therefore vary. If you do choose paint, I suggest you
prepare a batch in a jar to the correct density; trying to mix paint
and water as you go along will almost certainly produce uneven
marks, with some blacks too dense, and others over-watery.

A slate tray for grinding stick ink in water

Felt-tips

There are a vast number of pens on the market which go under all sorts of names – felt-tip pens, marker pens, fibre-tip and brush pens. They can be excellent, for some uses, but I do not feel that they are top of the artist's list of materials, rather an extension of this list for specific requirements. Many are expensive in relation to their short lifespan and, above all, the marks they make tend to be very obvious and not a little mechanical. This balance between the mark and what the mark describes is one of the most difficult aspects of drawing. The marks must exist for the drawing to exist, but in some cases one can hardly see how the drawing was made. If I say that I do not particularly like using large felt-tip pens because they make too obvious a mark, how can I accept the potter's use of a bamboo brush which also makes a mark exactly from the shape of the brush? Well, the joy of this subject is that no-one is right or wrong; the choice and the ultimate decision are for each of us to make.

Fixative

Some drawing materials smudge. Fixing them involves spraying the surface with a very, very weak glue – just strong enough, when dry, to stick the fine particles together and to the paper. Such glue

A felt-tip marker pen

is known as a fixative. Excellent proprietary brands are available and most, if not all, are now ozone friendly. The pressurized cans are simple to use, but you should always follow the instructions. As an additional precaution, spray the fixative onto a spare piece of paper first, just to make certain that it is fine and even. With some pigments and papers, the use of fixatives can result in a tonal change; for example, white pigment can lose its opacity. It is therefore advisable to carry out a preliminary test. Bottles of fixative are also available, although I always get sore cheeks from blowing down one of the two tubes set at right angles. This method is more likely to produce an uneven spray, and the tubes clog up after a time and need a good clean out, but it can be much more economical than aerosol fixative.

A spray diffuser for use with fixative. This will need cleaning out periodically with a piece of wire

Paper

Paper provides a surface on which a dry, mark-making instrument is ground. This relationship is crucial, and therefore no one paper can be said to be better than all the others. However, there are cheap and expensive papers. There are those designed for industrial use, like newsprint, the life of which is only a few days. Artists have found that this paper provides very large areas at a very low price. For students who are not thinking of long-term durability, it can be an excellent material, but only for certain types of work, as its 'dent' strength is weak. Any drawing instrument presses onto the paper, and the finer and harder the point the more it will dent the paper's surface and actually penetrate it. If the underlying surface is more of the same, the marks can even go through several sheets, but if a single sheet of paper is on a firm surface, like a drawing board, then its denting factor is much improved. Therefore only soft graphite pencils are safe on newsprint, although materials such as conté, chalks and charcoal can also produce good results. The time factor has to be taken into account, too, for although the first marks will be applied to pristine paper, repeated overworking will literally wear and tear.

Sugar paper has also been commandeered by the artist and is now made specially for drawing purposes. It is stronger than newsprint, and available in different colours. It is relatively cheap, but one must be aware that in some cases its colours are not light-fast. I have seen a dark purple-blue paper fade to pale buff within months when in sunlight. So it may be safer to stick to the off-white, buff sort of colours right from the start. Testing coloured papers is quite simple. Take a small rectangle and cover half of it with a piece of opaque material such as card. Tape it to a south-facing window and leave it. Examine the paper weekly to see if any contrast is noticeable between the uncovered and covered parts. Within two months changes, if any, should be seen. The thickness of sugar paper makes it much more durable, and it has a pleasant dry surface which makes it excellent for use with chalks and charcoal. Different thicknesses are available and I would suggest you select the 'heavyweight' variety when this can be found.

The terminology associated with paper is worth mentioning, as this will enable you to assess how thick it is. The measure now in use is in grams per square metre. For example, 100 gsm is an average thickness for drawing, while 300 gsm is much thicker and firmer, and for most drawing one would not need anything heavier. Formerly, the measure was given as pounds per ream (480 sheets) of a specified size. The greater the pounds the thicker the paper. For example, a good paper could be described as 140 lb or 290 gsm. (A quire = 24 sheets, each having a single fold; a ream = 20 quires/480 sheets, i.e. 20 × 24 = 480. Nowadays, with metrication, a pack or 'ream' is invariably 500 sheets.)

One of the merits of the thicker paper designed for use with watercolour is that the application of water is less likely to cause major wrinkles. Ink will not be a problem when used with a pen,

but an area of wash will affect most paper and make it swell, and all papers should be checked for their tolerance to wetting. If possible, seek technical advice before making a major purchase, and buy a single sheet so that tests can be made under your own chosen conditions.

It is possible to stretch paper to prevent wrinkling and, for a single pre-planned work, this can be worthwhile. Wet the sheet of paper by immersing it in water. Allow the surplus water to drip off and then sandwich it between clean absorbent sheets of newsprint (not printed newspaper) inside two flat boards. Leave for a while. Remove the damp sheet and, using a strip of water-based gummed paper, stick it down to a fresh flat board. Allow to dry completely

before using. A disadvantage of stretching is that it can be rather inhibiting, and artists worry about spoiling the finished work. Personally I prefer to use a good-quality paper, unstretched, so that when working outside I can make more than one study.

Some papers have an extremely smooth, almost shiny surface. These are used particularly by the printing industry. Ink will work well on such papers, but the pen will skid easily. On the other hand, pencil will hardly make a mark at all. A smooth watercolour paper is defined as HP (hot-pressed), while a slightly rough paper is called NOT (not hot-pressed). Rough paper has the most pronounced surface.

Ingres paper has a ribbed surface and is very compatible with chalks. Brown wrapping paper has a similar but more pronounced rib on one side, and is also good for use with chalks and coarse drawing materials. Most drawing papers have a front and a reverse side. Paper is made on a very fine screen, and the impression left by this can frequently be seen. In some cases it simply produces a slight variation in texture, while in others the marks can be rather 'mechanical'. Once again it's a question of choice and experience.

Damp paper stuck to a board with gummed paper strip

In time some papers will change colour and can develop spots. Atmospheric conditions may have an effect on some paper where acids are present in the manufacturing process. Acid-free papers are available for those who feel they have reached a stage when they require professional materials. Try to achieve a balance between quality, availability and expense. It is common sense to say that it will always pay to use the best materials you can afford.

Paper is sold in a number of ways. The single sheet will give you the chance to try out a particular type of paper, but do not roll it up, or it will be virtually impossible to get it flat again. Take a portfolio to carry it home, or reduce the size by folding it in half and later cutting along the fold.

Brown wrapping paper can be bought by the roll, but the paper will need to be pinned down flat before you begin to work. Packs of brown paper are of little use, for the creases cannot be removed. Large rolls of brown paper are available for commercial purposes, and a friendly shop-owner might be persuaded to give you a few feet to try.

Blocks of paper are available, backed with firm card. All sides are lightly glued but a single sheet can be removed by sliding a smooth paper knife round the edge. Considerable care is needed, though, for it is quite easy to scratch the next sheet with the tip of an over-sharp tool.

Drawing and sketching books (I have never found out what the difference is!) may have sheets glued at the spine, or one of a number of different spiral bindings. The latter are particularly useful, for the sheets can be folded right over while still lying flat. A2 is about the largest size of drawing book that is practical to handle. All such books have a cardboard backing, but generally only a paper front cover. This can quickly become dog-eared and torn, and I use a sheet of mounting card to provide removable

A sketch book with a ring binding

protection. Metal fold-back clips hold everything together and, when the book is opened, the same clips stop the sheets being caught by the wind. If using a bound drawing book, choose a relatively small size, for such books will not fold back on themselves without damage to the binding, and will also bend the sheets. A4 is probably a good maximum size, while A5 is happy to fit into a generous pocket.

A variation on the drawing book, which I myself use, is a folder made of canvas-covered card with a generous spine, containing a variety of individual sheets. The sheets are held in place by clips or an elastic band. Of course, the choice of paper will depend on the conditions under which it is to be used.

At home or in a studio, individual sheets of paper can be used on a drawing board. If you are going to a class, or working in a group, you may require a portfolio or a large stiff-backed pad. If you are travelling or working outdoors, the smaller drawing books become more versatile, while the smallest pocket book means that you will always have paper available for the unexpected.

A strong metal clip for holding paper against board. Note that the paper and board must be roughly the same size

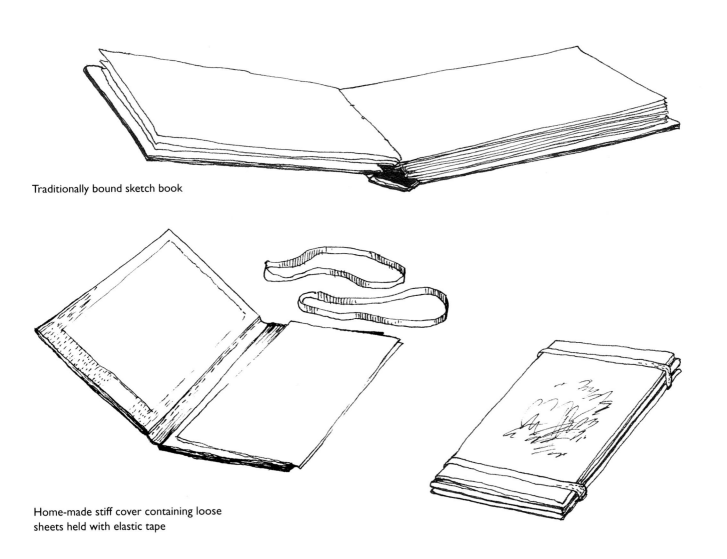

Traditionally bound sketch book

Home-made stiff cover containing loose sheets held with elastic tape

Setting Up a Studio

Expensive, elaborate equipment will not in itself produce good drawing but, on the other hand, trying to improvise can make some simple things almost impossible to achieve.

A basic studio can be set up in most homes. An area where things need not be moved or cleared up is quite a priority but, if this is not practical, you can make use of available furniture. Cover existing surfaces temporarily, using paper, hardboard or material. An upright dining chair can serve as an easel, and a piece of flat, firm board as a drawing board. Most problems encountered by beginners stem from working in a bad position. Trying to balance a drawing book on your lap is not likely to result in successful work, as distortions will be caused by the downward tilt. An easel will help enormously because it holds the drawing board in a more upright position, enabling the artist to stand back from the paper. The chair, in its less versatile way, can also serve this purpose.

Directional lighting is next on the list. A table lamp – or, better still, an adjustable spotlight – is required. When considering its position, thought must be given to natural light. It is important to be able to control direct strong sunlight, and for this reason studios are traditionally placed facing north, so that only indirect light reaches the room. Around this simple beginning the studio can grow. I think it is very important to see and pass by a drawing; to be able to view it at different times and under different lighting conditions will make the eye more alert.

A light wooden telescopic easel (below) and a heavier H-based studio easel (right)

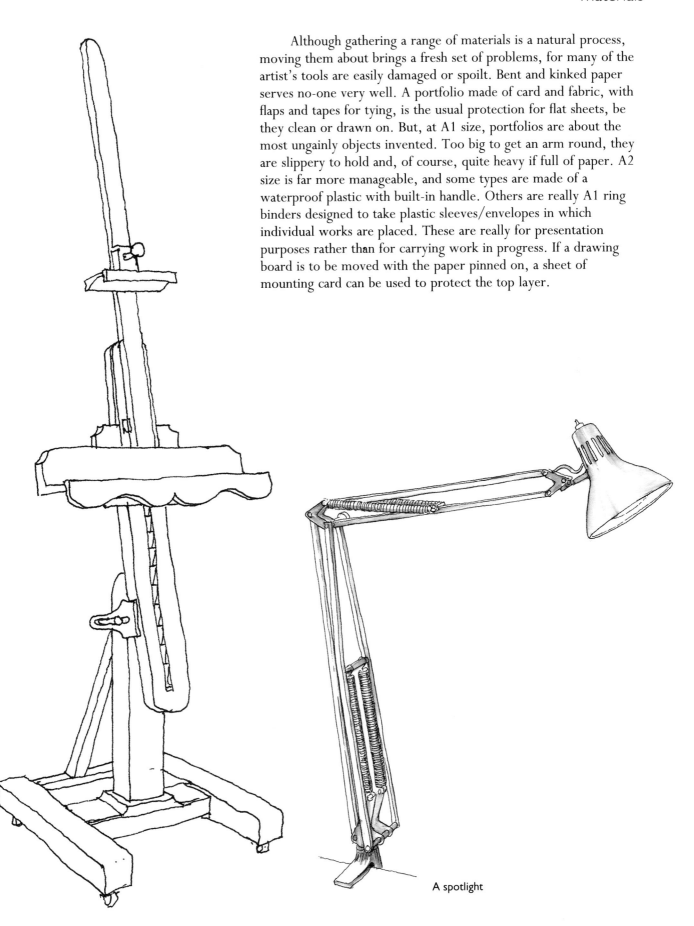

Although gathering a range of materials is a natural process, moving them about brings a fresh set of problems, for many of the artist's tools are easily damaged or spoilt. Bent and kinked paper serves no-one very well. A portfolio made of card and fabric, with flaps and tapes for tying, is the usual protection for flat sheets, be they clean or drawn on. But, at A1 size, portfolios are about the most ungainly objects invented. Too big to get an arm round, they are slippery to hold and, of course, quite heavy if full of paper. A2 size is far more manageable, and some types are made of a waterproof plastic with built-in handle. Others are really A1 ring binders designed to take plastic sleeves/envelopes in which individual works are placed. These are really for presentation purposes rather than for carrying work in progress. If a drawing board is to be moved with the paper pinned on, a sheet of mounting card can be used to protect the top layer.

A spotlight

Working Outdoors

The drawing bag is an all-round receptacle for the small items required by the artist. Many different types are found. I use what is called a 'country bag', which has a comfortable broad strap. Two internal and two external separate pockets, as well as the main compartment, provide segregation so that small items do not end up as a jumble at the bottom. But, like many bags, it gradually becomes home to just about everything that cannot find a place elsewhere, so I have to have frequent purges to reduce the weight. The main contents at any one time are likely to be as follows: drawing book, 250 × 360 mm (10 × 14 in, comprising a cover with loose sheets); drawing book, 250 × 180 mm (10 × 7 in, for use when not taking the bag); watercolour box; folder for brushes; metal box with range of pencils; plastic bottles with water; one ink

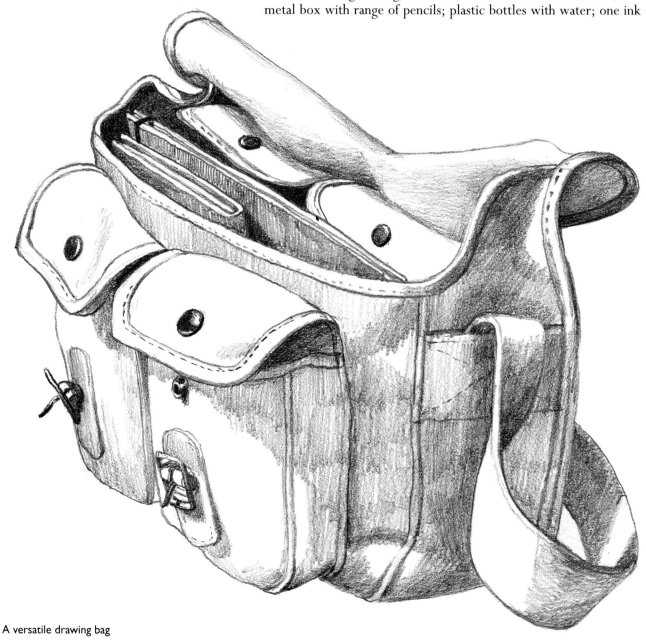

A versatile drawing bag

though it would be the same even if you were on top of a high cliff. In this exercise, the still-life group is to be below this eye-level line. If you are standing, it could be on a dining table or, if sitting, on a low table 450 mm (18 in) from the ground. The reason for this position is to create sharp angles, making the lines of the still life clearer to judge, and the spaces between objects more apparent. Think of the group as lying on a mini-stage. A lamp placed on one side, right or left, will define the shapes by creating shadows. This may be unnecessary if your room has a north-facing window and you always work in daylight, but I find that daylight can vary enormously, from noon on a clear-blue summer's day to early evening when there's a thunderstorm. It is, of course, a matter of choice, but it can be very calming to have exactly the same lighting conditions whenever and for however long you wish to draw. Even when your objects seem satisfactorily arranged, check that a slight movement to left or right will not produce just a little more tension between the shapes. My meaning here may seem a bit obscure, but even if these simple objects forming the still life have never been together before, they are now, and thus begins a magnetism which you, the artist, have to find. As your experience grows, only you will know just where the right point of observation is.

Step 2: Gradually the elements of the composition can be built up. If some lines overshoot the object, let them be, for they will emphasise the directions of the parts even more emphatically

The exact position in which you stand when drawing is very important, so remember to make a note of it. It may be a point on a carpet or floor tiles, or you could mark it with chalk, crayon or adhesive tape. This will enable you to return to exactly the same drawing point.

Your drawing board should be as close to the subject – again left or right of it – as seems most convenient (or, if propped up, it could be below it), but not so close as to make you peer round or over the edge to see the whole of the subject. If you are working in a standing position, the board on an easel should be reached comfortably with your arm stretched out. One of the most common faults is to stand or sit too close to the drawing; this can lead to poor judgement of proportions (amongst other things). If you are sitting on a chair or stool, use another chair to support your board. If you are holding a sketch book, it should be in a near-vertical position. If you allow it to slope downwards on your lap, your judgement will again be impaired. Mark the position of the easel or chairs if they are likely to be moved. In the same way, the position of the objects forming the still life should be marked on the table. The marks do not have to be heavy – a pale pencil line or chalk mark is enough – but it really is important that, should the group get moved, it can be placed back exactly as it was: roughly right is not good enough. If an object is circular then make a mark at one point on its circumference so that it cannot be rotated from its original position. I have had many frustrating conversations with pupils who have not bothered to mark their place or objects, and who then make the excuse, 'Oh, it's all been moved!' Usually it is they who have drawn from more than one position. Some tutors might feel that all this is quite unnecessary, and is not likely to make a good drawing. I agree, but what it may do is to prevent a bad one, and it provides a calm environment in which the artist can concentrate entirely on the drawing.

Use an A3 sheet (420 × 297 mm, or 16½ × 11½ in) of white cartridge paper (96 gsm) and a 2B pencil, and have an eraser to hand. Do not worry about the size of your drawing at this stage. It may or may not fill the paper.

Make a drawing similar to that on page 34, using the five objects you have chosen and working as described above. Try this drawing as many times as your enthusiasm and staying power permit. When you have had enough, put the collection on one side, keeping the sheet of paper on which the positions have been marked. You may like to return later to the same subject, setting up in exactly the same way, but trying different views, materials and approaches.

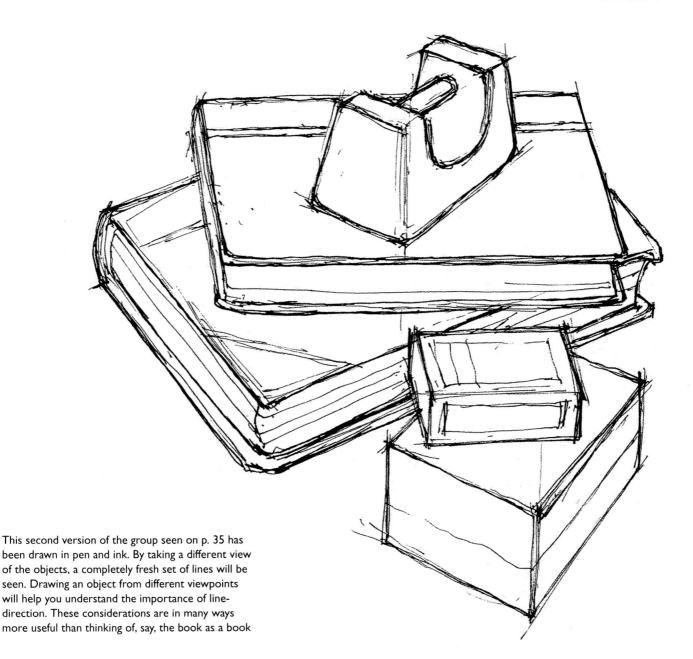

This second version of the group seen on p. 35 has been drawn in pen and ink. By taking a different view of the objects, a completely fresh set of lines will be seen. Drawing an object from different viewpoints will help you understand the importance of line-direction. These considerations are in many ways more useful than thinking of, say, the book as a book

lesson 2 # Tone

To explain the meaning of the word 'tone' is one of my hardest tasks as a teacher. 'Line' and 'colour' are not difficult to define, but 'tone' is more obscure. It refers to the darkness or lightness of a colour, and also to the relationship between colours. Thus yellow will have a paler tone than black. However, tone is more often used to signify the amount of light being reflected from a single colour. If we look at a car standing in the street, we can see that the top of the roof appears paler than the lower part of the doors. Of course, this is helped by the fact that the surface is very shiny, but matt-surfaced objects will respond to light in a similar

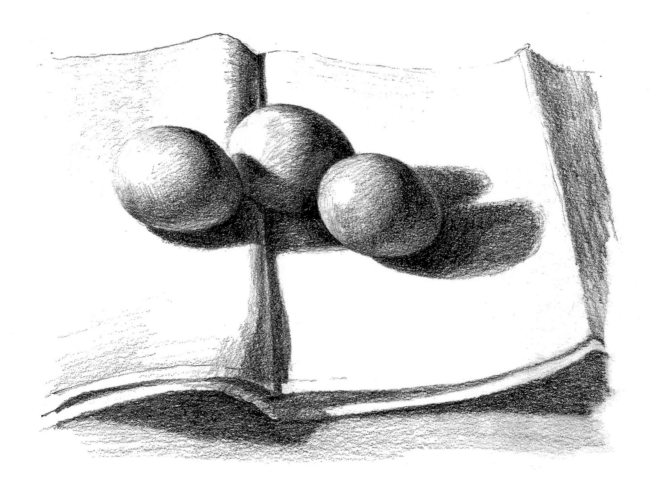

way. Look at any solid object with light falling on it from a single direction, and you'll see that surfaces away from the light have a darker tone than those in the stronger light. The folds in a jacket sleeve show this well, also.

Try the following experiment. Take a piece of opaque black paper or card – a 10 cm (4 in) rectangle will do. Then take a piece of white paper or card – it must be opaque, so if necessary fold a larger piece down until no light penetrates. Prop up or stick both rectangles on a high window with the sky behind them. Then, from the other side of the room, look at them against the light sky. Both black and white will appear dark and, if you half-close your eyes, little difference in their tone will be apparent, even though one is black and the other white. This is because sunlight is much stronger than we realise. Indeed, if the sky is dark grey and very overcast, the white rectangle will still be much darker than the grey sky, although in colour terms we would say that grey is a darker tone than white.

a

a This stone has a dark and light pattern
b When lit from one side, the contrasts in the pattern are reduced and shadow is created on the stone, which fuses with the cast shadow on the table

b

Now take down the black rectangle and fold it in half, making an L-shaped bend. Place it once again against the window, abutting the white rectangle so that the upper half of the black paper faces into the room and yet still catches some light. If you adjust the angles, it will be possible to make the top half of the black rectangle appear paler than the white rectangle when viewed from across the room.

Colours and tones are therefore not absolute but change according to their surroundings and the lighting conditions. It is crucial to appreciate this when drawing.

The eggs in this drawing (left) have a plain, even colour all over. The light (or lack of it) will create some variation in tone, which will help to show the volume of the object. Notice how the shadow on the page also tells us something about the shape of the surface, and the way the tone of that surface changes

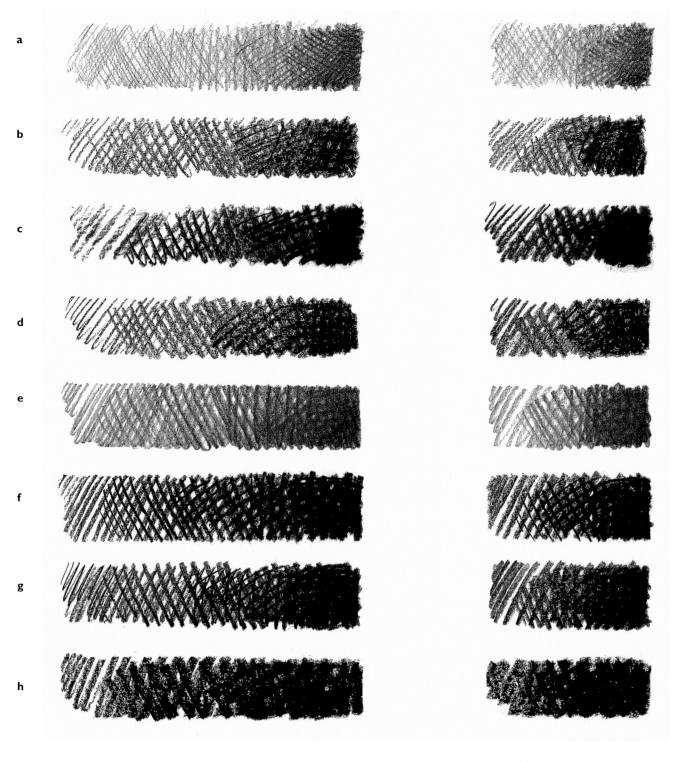

Samples of cross-hatching using soft materials

a 9B pencil
b Black conté
c Charcoal
d Black wax

e Graphite stick
f Charcoal pencil
g Broad ivory-black pencil (Derwent). Note that, unless the pencil is held very carefully, the full width is not used
h Oil pastel

Though cross-hatching is usually associated with the pen, its 'building-up' technique is suitable for use with other drawing instruments as well. It is probably best to use cross-hatching to create tone at an early stage. Later it will merge with other techniques used to build up the drawing, and all these textures will themselves be tempered by the texture of the paper.

Arrange three balls so that they are lit from one side, either by north-facing daylight or a lamp, and draw them tonally.

Step 1: Very lightly describe the boundaries of the three balls and, without developing any one, apply some shading where the main dark areas occur

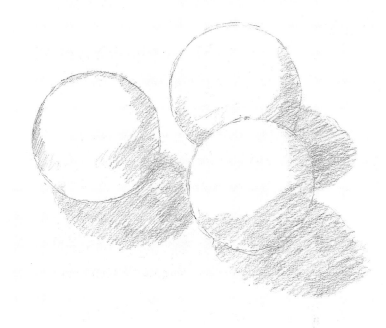

Step 2: Work over the whole group, strengthening the darks and preserving the very lightest areas by leaving the paper totally untouched

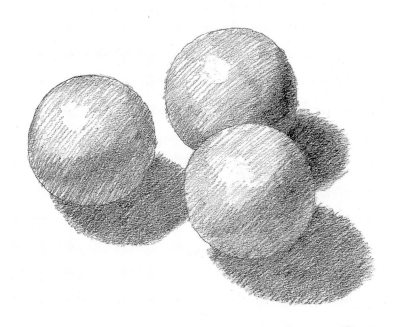

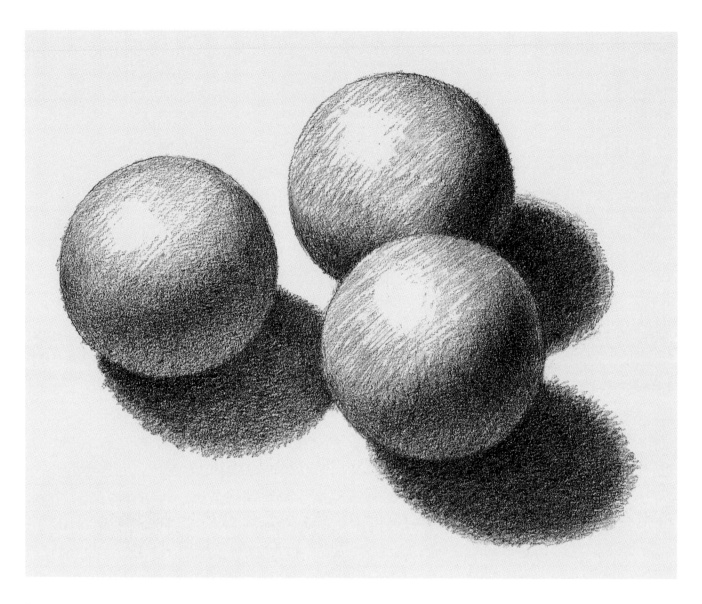

Step 3: Continue strengthening the tonal values, noting the reflected light coming off the surface of the table. Do not make this area too pale. It is a common fault to exaggerate reflected light. Keep the edge of the shadow soft and the gradations of tone even. This exercise will give you practice in manipulating the pencil and controlling its application

lesson 3 # Shape and Surface

This exercise involves a plant. Choose one with large, simple and clearly shaped leaves, and not in flower. If it is in a clay pot, so much the better; I hate drawing plastic flower pots! Stand the plant on a simple saucer or plate to enable it to be watered. (Strange how many artists will let their subject matter die before their eyes!) Concentrate on the plant, not the pot; try taking a view looking down, with perhaps only a glimpse of the container.

While the still life in lesson 1 was mainly made up of straight lines, the plant is full of wavy, bending lines with quite a variety of shapes being produced by the leaves. Try two drawings, one with a 2B

This plant produces a mixture of wavy lines, curving shapes and different tones caused by variations in the surface and the light

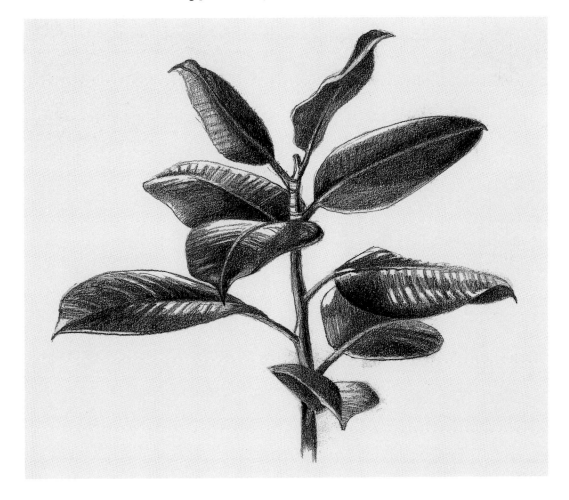

pencil and one with perhaps a 6B. Then attempt an entire drawing in five minutes. Repeat this exercise with a variety of drawing materials. Using a range of materials in this way will enable you to gain experience quickly and, although not every sketch will be successful, you will soon realise that there is always more than one method. What will also become apparent is that the same object drawn by the same person will be slightly different each time. Proportions will vary, though each will be thought correct when considered separately.

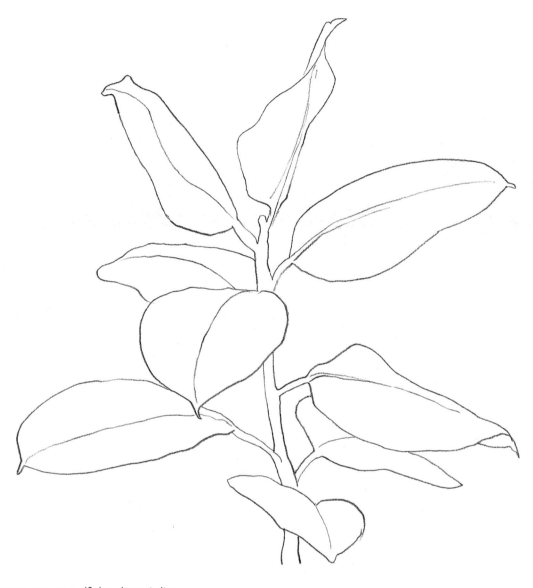

The same plant as seen on p. 43, but drawn in line only. This study was made very quickly, keeping the pencil in contact with the paper for as long as possible. Do not use an eraser; try more than one drawing instead

lesson 4 # Tonal Practice

Another simple group of boxes and books, this time in charcoal with emphasis on the tonal relationships

For your next drawing exercise, set up a still life with boxes and try making a tonal version of this, using charcoal. It is, I agree, quite a messy material, and bits break off easily, with much of the stick falling as dust on the floor. The subject will be the same as in lesson 1, but this time I suggest you cover the entire paper, making some areas very pale and others as dark as possible. Sugar paper does not come in pure white sheets (at least I have never found it), but it does exist in

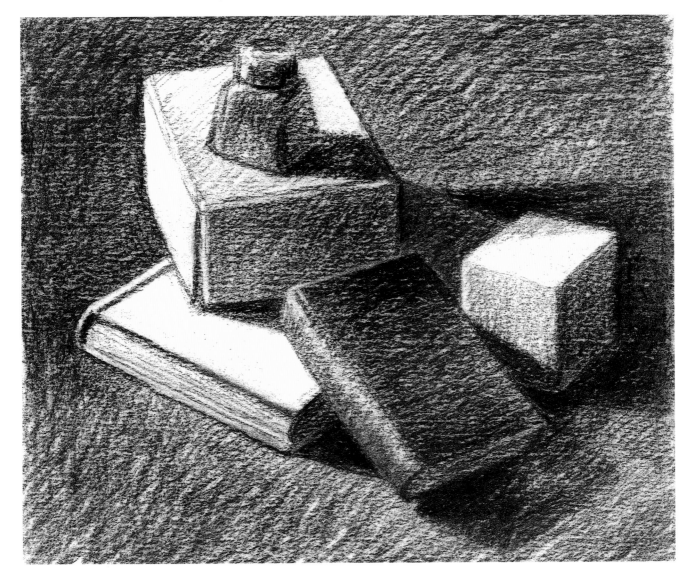

a very pleasant, pale, off-white buff. If this is available, try using a sheet. If only white cartridge paper is to hand, then use that, but don't worry about making the whole area grey. For this exercise do not smudge the charcoal with your fingers; although this can be effective, it does not give the same control over tones as can be achieved with gentle overlays of cross-hatching.

Try to achieve a range of tones in your drawing, using the cross-hatching technique, working a second and third set of lines at different angles to the first. This will create a sort of trellis-work, a criss-cross of marks with patches of untouched paper between them. These patches are very important in drawing, as they help to maintain a lighter tonal value. Once covered, they can only get darker, and some of the sparkle from a surface will be lost.

Tone will therefore be found to come from more than one source – the material (so that the darkest 2B pencil will not be as dark as conté) and delicate application with pencil, charcoal or conté, keeping a broad contact (using the flat side of the material rather than the actual tip). The dimples in the surface of the paper will have an effect here and determine how much white remains. Finally cross-hatching lines will help you control the tonal density.

So even at this relatively early stage a language begins to form. The materials control some aspects of the work, the light controls others and time yet more. The size of paper used is also significant. An A3 sheet is probably adequate for students' first attempts, although individual artists can work on very different scales, and my advice can only be a rough guide.

Try a charcoal version of your still life, using an A1 sheet (841 × 594 mm). Don't put down any marks until you have considered how the shapes of the composition will fit into the larger sheet of paper. Make the objects much larger than in your original line drawing, and plan your work so that the shapes fill out the sheet. Do not draw the shapes in pencil first.

This particular point needs emphasising, for I feel quite strongly about it. If you are using conté or charcoal, or pen and ink, do not lay out the drawing in pencil first. Often the pupil lays out a drawing in pencil, to continue, say, in conté. 'Well,' they say, 'it's just a rough to work out the main shapes.' Then they develop the actual drawing, closely following their 'rough' pencil layout, only to find after a time that their first thoughts were not at all accurate and so did more harm than good.

Technique needs to be related to experience and, in the early months of learning to draw, it is important to establish the right approach. Later, when experience has grown and judgements are formed, rules and limitations need not apply. The marks and shapes will depend on what – hunch, feeling, flair? It is difficult to teach hunch. With practice, you will come to identify the techniques and materials that are right for your work.

So for this charcoal study, stand well back, work large and bold, and think tone.

Chapter Three

scale and space

When drawing it is important to get works completed; whether you are making a five-minute study or one lasting several hours over several days, a conclusion should be reached. Much can be achieved by making the attempt and getting to a point at which it is possible to make some assessment of the result. It is quite easy to hide behind the unfinished work, thinking about what might have been rather than what has been achieved. But no one drawing can encompass the entire learning process, and it will constantly be necessary to return to the basic points in order to take them one stage further. Having completed some drawings, you are now in a better position to begin a process of closer analysis.

A line has a direction and it travels for a distance. How that line relates to another and how they compare in their proportions just about sums up one of the basic aspects of drawing. I depend on observation when drawing, but I also know that some thoughts of a more analytical nature can tell me whether my hunch, my eye, is making sound judgements. In other words, is my drawing accurate enough to hold together so that it feels comfortable? Many other qualities will have to be there if it is to be a good drawing, and those qualities are more difficult to teach, but the basic structure can be taught. It is, of course, up to the individual artist to decide to what extent these basics need to be used, but an ability to draw will give you freedom of choice rather than restricting your work.

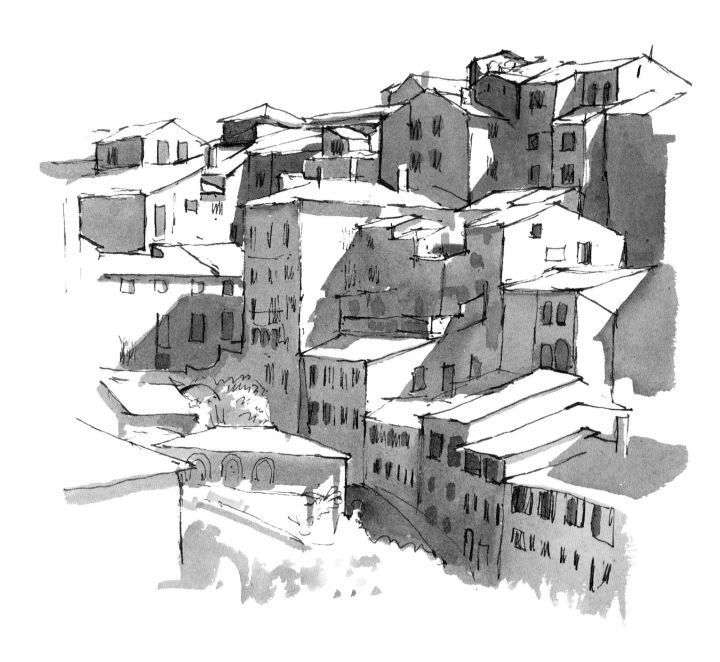

Siena, Italy. These buildings below the Duomo were
in strong sunlight. Their proportions were especially
important, as the light and shadow were totally
interrelated. The drawing was completed in about
forty minutes. Even in that time the shadows had
moved considerably, which meant, of course, that
the angles had changed

lesson 5 # Proportions

Set up a group of wooden or cardboard boxes; the sort one collects weekly groceries in would do very well. Clear an area on the floor and arrange them in a jumble to give different angles: one leaning on another, one on top of another. Mark with chalk where they touch, and use pieces of tape to mark the main corners on the floor. Arrange a light (this is where an angled desk lamp will come in useful) so that the lighting comes from one side, creating strong shadows and making some of the main edges stand out clearly. You will need a 2B pencil, an A1 sheet of paper and a 50 cm (2 ft) stick, for example a length of dowel, a very straight piece of bamboo, or even a very long knitting needle. Stand as if you are going to view the group and consider the horizon/eye-level straight ahead of you.

An arrangement of cardboard boxes. This gives the basic appearance which will have been judged from the thoughts represented in the next three images

Use the long stick to establish this in your mind. Then, keeping the stick horizontal, move it down so that it is in front of the group of boxes. It will now be parallel to the horizon but below it. I call this a 'useful horizontal'. The stick now represents an imaginary line right through your group. Turning to your paper, draw a faint pencil line across it, without using a ruler. The drawing will now be 'locked on', as it were, to the group of objects, for the horizontal will remain common to both.

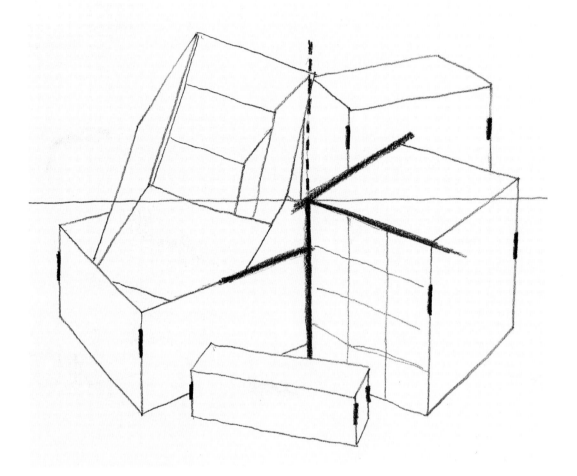

The horizontal line should be established first. Use one that coincides with a meeting point of other lines. In this case the horizontal crosses a clear vertical. Below it is the edge of the wine box; above it, I have continued the vertical as a dotted line. Start the wine box at the corner and decide on the angles made by the edges and the horizontal. I have also thickened parts of the vertical edges of the other boxes. Remember that all these lines will be drawn as verticals

Observing one of the boxes, select an edge and use your stick to establish the angle (e.g. 30°) related to the horizontal. Then, facing your drawing, repeat this angle to establish the line of your box. Continue to use your stick to help you establish all the other angles of the boxes, in relation to the horizontal and vertical.

 Now attempt a drawing, concentrating on the three aspects shown here.

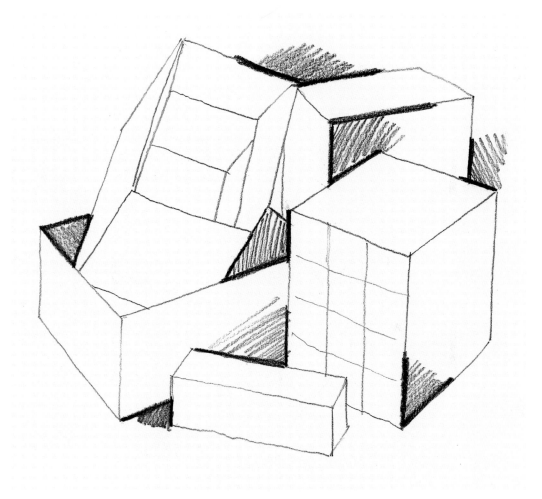

While you are thinking about the direction of the lines, you should also consider the spaces or areas between them. In this diagram of my thoughts I have emphasised several of these corner spaces. By giving emphasis to the 'holes', you will find that the shapes become important in their own right rather than just being part of one box. The central shape here, in fact, becomes part of four boxes

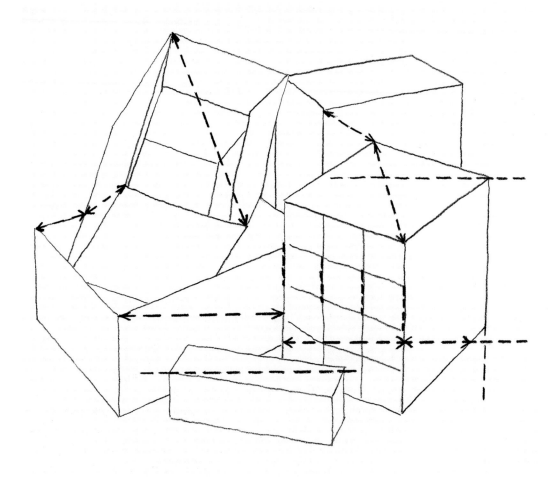

This diagram shows a third way of thinking. The
dotted lines represent the artist's thoughts (not
drawn lines) about two corners or two lines. Some
use a horizontal, some consider the angle between
one corner and another, while others consider which
is the larger of two or more measurements. Most of
the dotted lines do not follow the edge of a
structure. Only the very left-hand one does so, and I
put that in because it just happens that its
neighbouring dimension is approximately the same
size. Simple facts like that can be very helpful

lesson 6 # Positive Shapes

Select the most simple dining-room chair you can find. The one I have used in this sequence is ideal, for it provides a near-regular set of shapes without decorative or wavy additions. This type of chair is very good for drawing practice, and will introduce new ideas relating to the concept of space. Think of the chair as having four main verticals of wood with some bars across and a flat piece to sit on. All the considerations we brought to the cardboard boxes in lesson 5 apply here – what are the ratios of lengths, and at what angles do the edges lie to the basic horizontal? But it is also possible to consider the chair in another way, by thinking of the spaces between the elements, and to get a feeling for it by not actually drawing the wood at all. If the lines we put down represent the edges of the spaces between the wood, the chair will have been described quite accurately. You might therefore think that whichever way you treat the drawing – as wood or air space – the result would be the same, but, curiously, that is unlikely to be the case. If, when drawing the chair, the air spaces are considered only after the drawing is finished, I would expect inaccuracies to be noticed. Some of the 'holes' will have the wrong proportion; some of the legs or cross bars may be too thick or too thin, and the points where the legs meet the ground may be questionable.

Drawing with a pen makes one think first, for the mark, once made, cannot be removed. Again, do not use a pencil to 'lay out' the shapes, but make dots with the pen and put down the lines bravely. If, as you draw, you need to make adjustments, simply make another mark or line in the new place. Think of the drawing as scaffolding.

Students often put a mark down and then feel it should be somewhere else, which makes the first mark incorrect. This feeling is wrong. Indeed, a good quality is often produced when differing marks accumulate, producing a feeling of life and movement, a sort of distillation of thoughts about the object. Using the pen makes you tough. You have to commit yourself and I would certainly recommend persevering with it when trying to come to terms with structural directions and proportions.

scale and space

A simple dining-room chair drawn in pen and ink.
Dots or short lines are just noticeable, indicating my
thoughts about the relationships between parts. The
spaces between the wooden parts are as important
as the parts themselves in this drawing

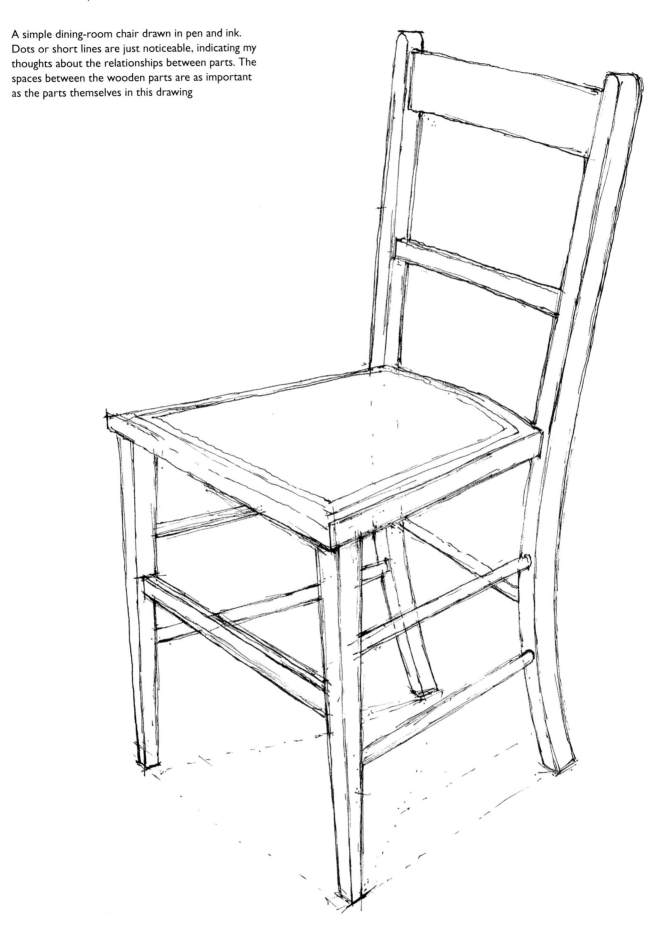

lesson 7 # Negative and Abstract Shapes

In the previous lessons, I have purposely used relatively simple objects, but these have only been a guide. The choice of subject matter is dictated by what is available and what engenders some degree of enthusiasm. Do not get caught out by the idea that a nice or beautiful object will necessarily make a nice or beautiful drawing. The drawing will be an equivalent in drawing terms, not a reproduction. Small parts of an object, a building or a landscape, may need to be omitted in order that other qualities can be given emphasis. Good drawing tends to ration the qualities shown. In the case of the chair in lesson 6, the subject will probably be made of wood, possibly varnished, and will therefore be fairly dark in tone. In order fully to appreciate the proportions and the directions of lines, try to give the chair a lighter tone in at least one drawing.

If you can sustain your enthusiasm for the chair, it is worth trying a second and quite different approach. For this you will need some paper of a middle to dark tone; a half-tone grey sugar paper would be ideal. The term 'half-tone' is a pretty broad one. It simply refers to a value about midway between black and white. The matt, slightly ribbed back of brown wrapping paper can be an excellent half-tone paper.

This drawing is to be made with a white pencil, and you should carry out a pencil-on-paper test first. Some pencils can be very hard and will not leave pleasant marks on soft paper. On the other hand, some conté-type pencils can be quite crumbly and soft, and are unsuitable for use with very smooth paper. A fixative test is also advisable, as some whites can pale under certain conditions.

Take the chair you used for lesson 6 and set it against a pale floor and background. It may be possible to drape a white sheet down the wall and across the floor. You are going to make a drawing of the wall and floor. The chair should be left as virtually untouched paper. I say virtually because dots and marks may be added as necessary as the work progresses. However, in broad terms the chair will remain as untouched paper while the white pencil will work its way over the spaces within the chair's structure and over the background.

Your first thoughts about the composition may go something like this. The sheet of paper is, say, A3. The chair is roughly twice as high as it is wide. The background to the chair is simply areas of white pencil. How much does one want to put in? There are no laws governing composition; however, some judgements have

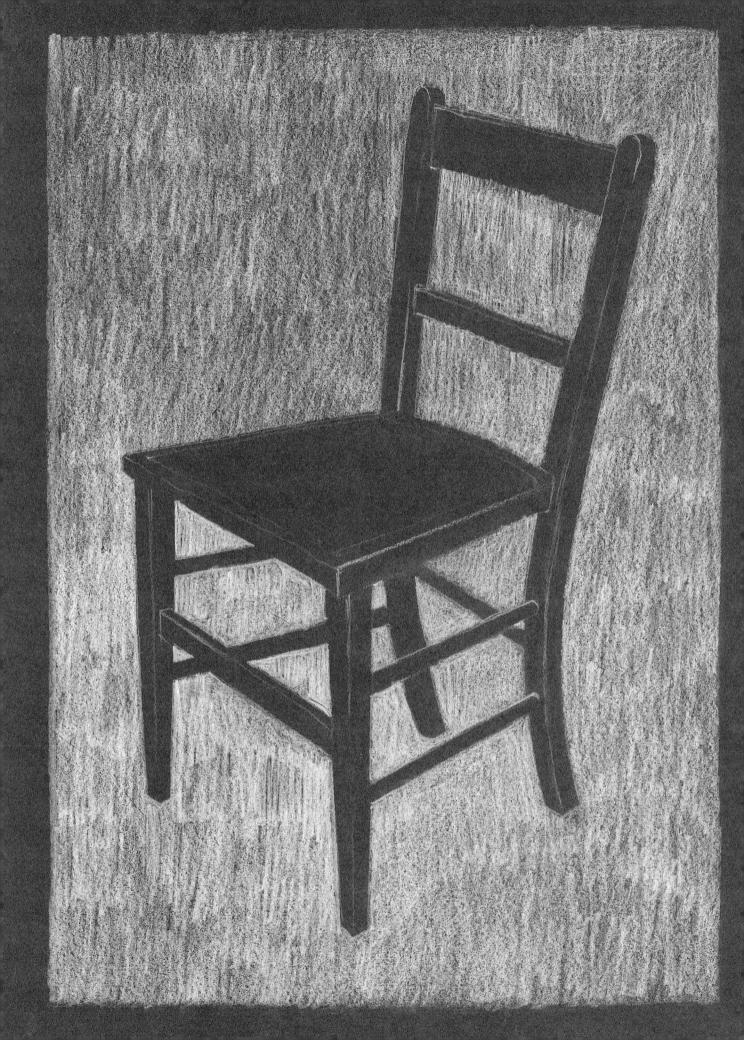

An old card mount cut into two pieces can be a most useful overlay to select parts of a drawing

to be made. Are the shapes within a picture comfortable or uncomfortable? The question may not be easy to answer, but it is important to start making decisions about this aspect of the drawing as well as concentrating on the object itself. This is where the word 'background' can be so unhelpful. It seems to suggest an area of secondary importance. But in this exercise, the white area behind the chair is the drawing, and without it there would be no chair at all, so a decision has to be reached concerning the limits of the rectangle.

A drawing does not have to take up all the paper. I suggest you set a boundary inside the actual edges of the paper, leaving you with a shape that makes the area around the chair seem comfortable. If there is too much space, the chair could look very small and lost – though you might like this effect. If the space is too small and the boundary too close to the edge of the chair, your subject might feel a bit jammed in, as if it were in a cardboard box. Somewhere between these two extremes is probably comfortable; but whether it is or not hardly matters at this stage – it is thinking about it that is important.

The word 'abstract' is one that features strongly in the world of art. It is often thought to refer to a distinctive style of drawing or, more commonly, of painting, which people either like or loathe, and which produces comments such as 'Can't see anything in it' or 'Anyone could do that'. Yet the drawing of the chair on which you are working can be strongly abstract.

Take a large (unwanted) picture mount and cut it at two diagonally opposite corners. Alternatively, cut out two L-shapes from a large sheet of paper. These will be enormously useful, for they can be laid over a drawing to modify the centre space, making it tall and thin, broad and shallow, square, large, or tiny. In the same way, different parts of your drawing can be considered in isolation, and the whole composition can be studied without altering the actual drawing at all. (Just take care not to smudge an unfixed drawing.)

If the two L-shapes are laid over the main outline of the chair, some dark and light areas will be left which will have lost most or all of their 'chairness'. The quality of these remaining shapes will be totally abstract – just rectangles of tone.

So even if you are working from an actual object with a known identity, your drawing will have an abstract quality. To what degree this is apparent will depend on the composition of the shapes you select.

A second version of the chair in the previous study, drawn with white pencil on a dark but not black paper (left). Here the chair itself is hardly described at all. The background and the shapes seen through it make all the description

scale and space

A quite abstract set of shapes selected from the drawing seen on p. 56

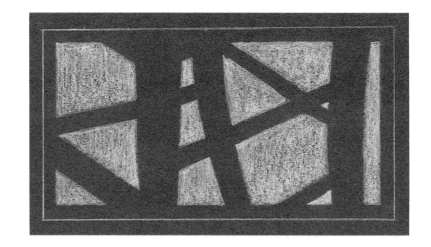

An early stage in a study of part of a motor cycle, worked using 2B pencil on grey sugar paper, with white poster paint/gouache establishing the positive nature of the spaces

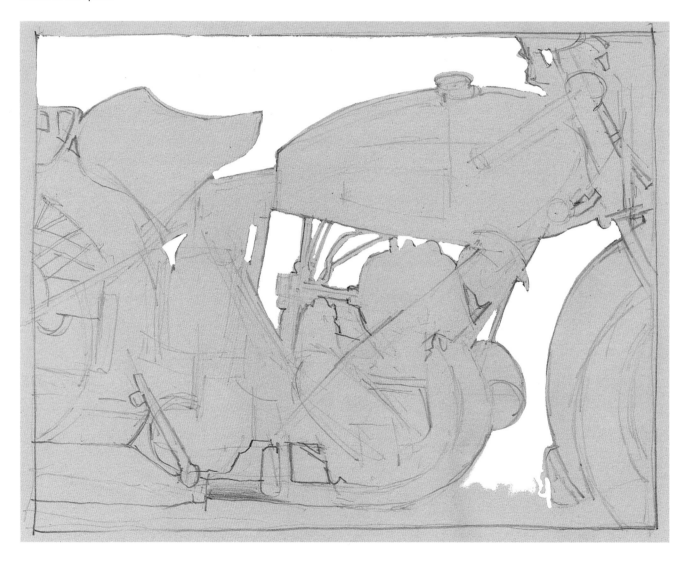

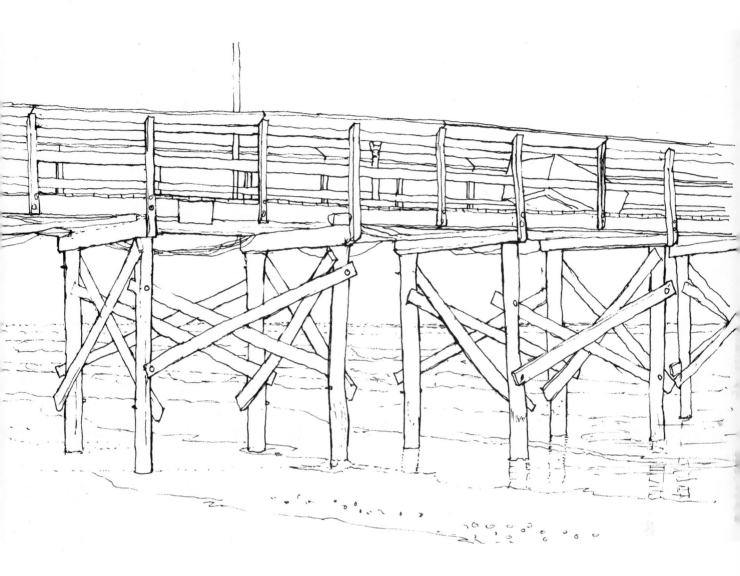

A pen and ink drawing of an old pier in South
Carolina. The spaces were vital in determining
the layout

The corner of a studio,
drawn with conté pencil.
A drawn boundary helps
to define the composition

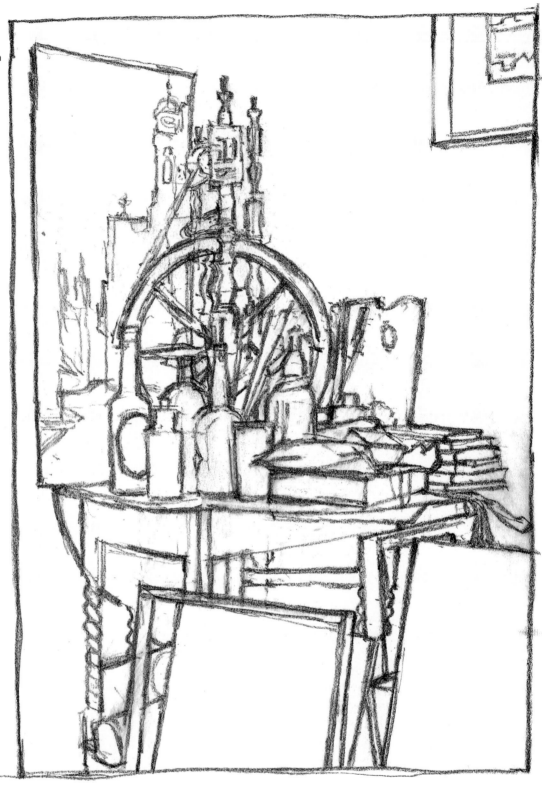

Chapter Four

structure

A friend once described my art teaching as being concerned not only with what was observed, but with what was there. I had never really thought about it like that, but it is true, I set great store by an understanding of structure. While it is not necessary to study cabinet making in order to draw a chair, geography to draw a landscape, or architecture to draw a house, a curiosity about your subject is enormously helpful.

I have seen some terrible drawings, in which the intention was quite clearly to represent, say, a house, but the result looked like a cardboard cut-out. The marks in a drawing are two-dimensional but the subject to which they are linked will be three-dimensional. It is this translation which is so crucial. (That is why copying a photograph often produces unsatisfactory results. The photograph is already two-dimensional and so, of course, it's easier to copy, but such an exercise does little to make the eye truly aware of the subject, and the results generally look like what they are — a copy of a photograph.)

Find a shopping basket or a log basket. Put it on a table as if you were going to draw it. Stand back and, without counting, make a quick guess as to how many vertical canes there are. Now count the number of verticals you can actually see. I predict that it will be fewer than your estimate of what you thought you could see. Most subjects look more complicated than they really are.

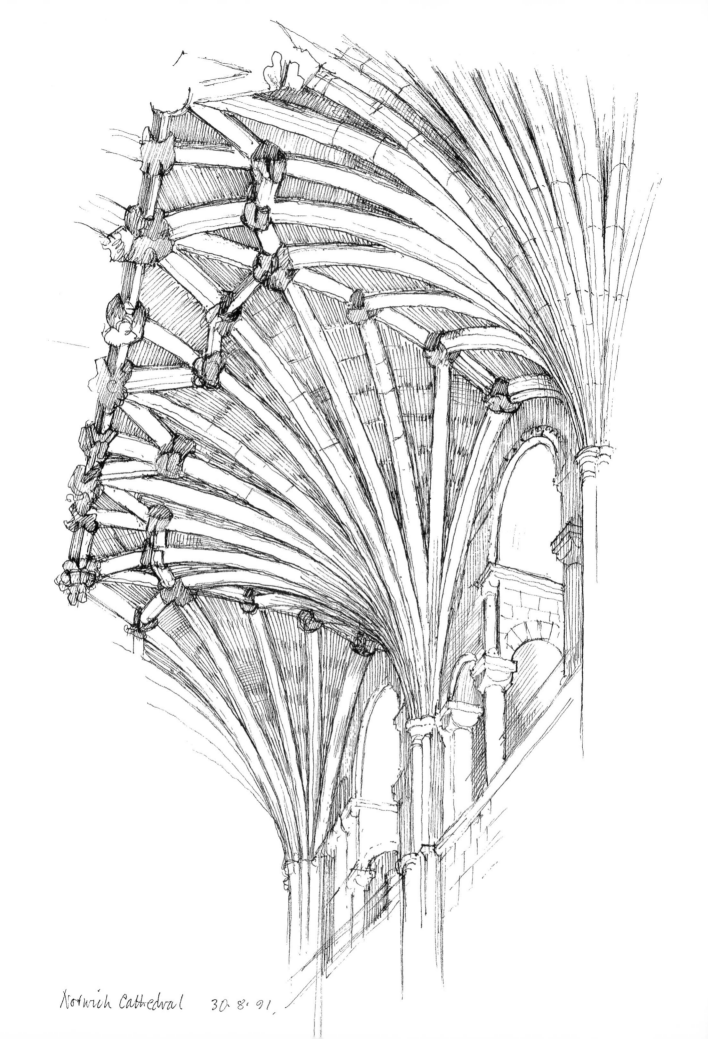

Norwich Cathedral 30·8·91

Part of the vault at Norwich Cathedral (left) – a complex stone structure requiring careful observation of directions of curvature. Because one element in a vault has to relate to another, I found it helpful to consider three springing points covering two bays.
Pen and ink on watercolour paper

I once found myself with a brief moment to draw by the Thames. A masted ship was anchored ahead and I made a drawing stern-on. Some parts of the rigging, crossing the main masts, appeared to tilt upwards slightly and I drew them like that. When I had finished the drawing – it was only a twenty-minute study – I walked towards the vessel. I looked at the rigging and realised that I had misunderstood the structure. The parts which I had thought had a upward tilt in fact were angled backwards – like a blunt arrow shape. My drawing then looked wrong.

So drawing works in two ways. You have to know and understand the nature of an object in order to make a good drawing, and by drawing an object you will get to know it better. Man-made objects are probably easier to analyse, for their structure will usually be more logical. You may be able to see the order in which they were constructed, and their function may be related to their shape. They will have been made from materials of different thicknesses, and their shapes will have come about through different processes. The artist's knowledge need not be deep, indeed it may be superficial, but it should be enough to keep the eye on track.

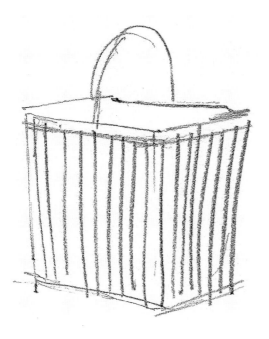

A very quick drawing of a shopping basket (above), showing eighteen verticals
2B pencil

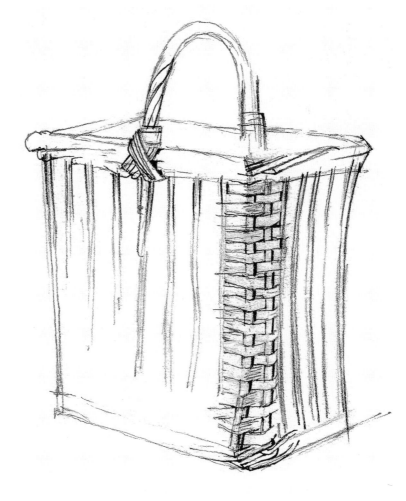

The beginning of a more considered drawing of the same basket, worked in 2B pencil (right). The actual number of vertical elements is fifteen

lesson 8 # Man-made Objects

A length of synthetic rope (right).
2B pencil

A silver chain drawn much larger than life size (right).
2B pencil

The lip of a metal jug (below)

The lip of a pottery jug. Notice how much fatter the edge is when compared with the metal jug (below)

Make a series of drawings showing a range of manufactured structures – different curves, joints and thicknesses, such as those seen here.

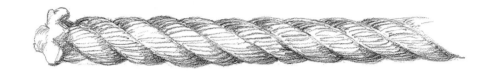

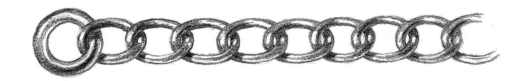

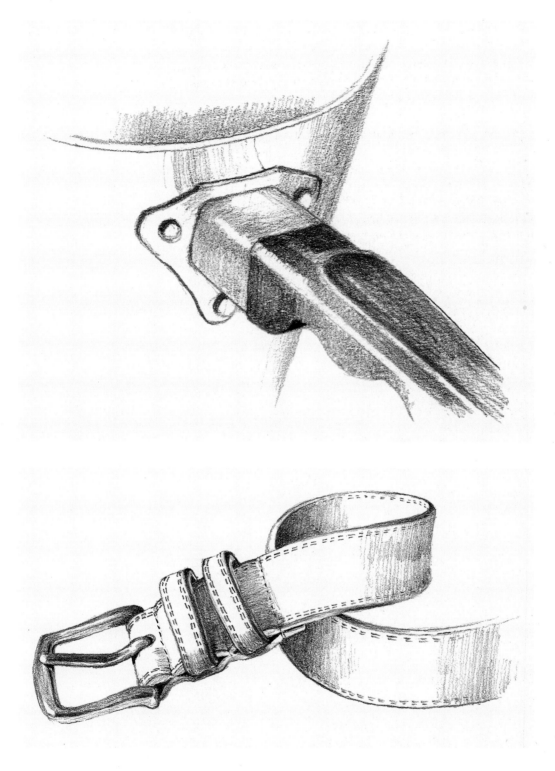

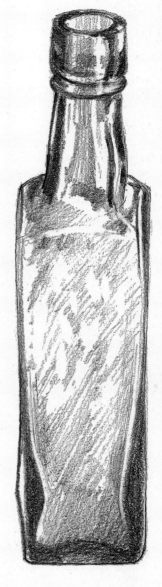

Part of a metal saucepan showing the plastic handle and the rivets (top left)

A leather belt with a brass buckle (bottom left). Notice how the curves are related to the way the material bends

An old glass bottle (above). The material is not of an even thickness, and also reflects the surroundings

lesson 9 # Natural Objects

Nature creates structures much more complex and subtle than those of man, with an enormous range of shapes and textures. One of the most important factors to take into account here is growth. The pattern of growth will give rise to many different shapes and textures. So in one object there may be evidence of a number of different stages – from new shoots, to fully mature leaves, to ones which have fallen. In landscape the changes are there as well, but on a larger scale. It will help the artist to be aware of how mountains are formed, and of the nature of their erosion. In some cases the presence of man will be seen, and there will be a set of elements which are locked in a sort of visual battle. The coastline is a good example of this: here cliffs may be eroded by the action of the sea, while man constructs defences to curb this. In turn, these defences get eaten away by the force of the sea.

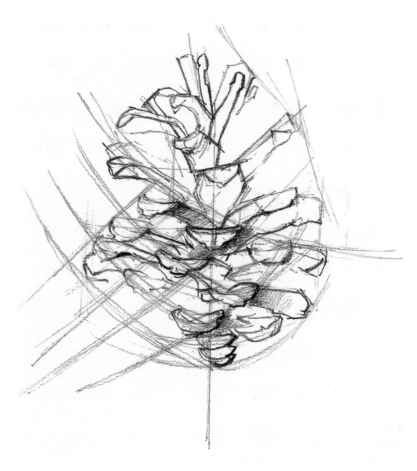

The beginnings of a drawing in 2B pencil of a fir cone.
Verticals are indicated as well as the spiral sweep of
the separate elements

Make a further series of drawings such as the ones shown here, analysing natural forms. Remember, however, that an understanding of an object's basic shape, and even a correct assessment of the directions and lengths of its lines, may not alone result in a convincing drawing.

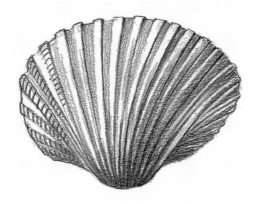

A shell. The description of the parts that stand forward and the parts that are set back between them is helped considerably by the outline of the form

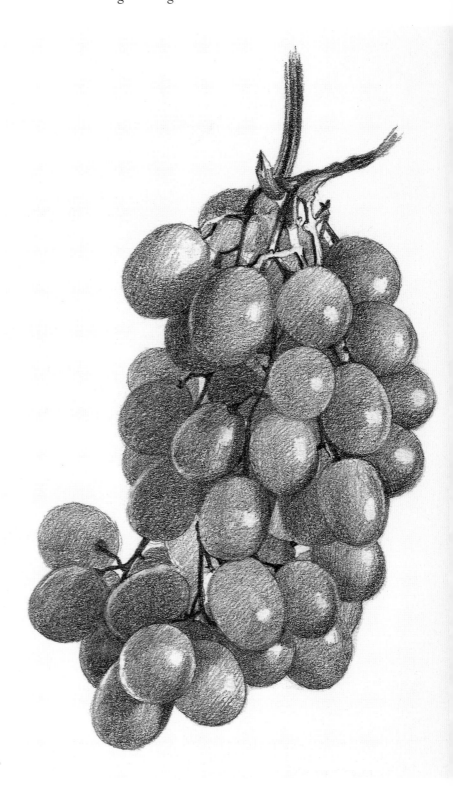

A bunch of grapes. The volume of the bunch is indicated by the fact that not all the grapes have a shine. Some also cast a shadow on others. 2B pencil

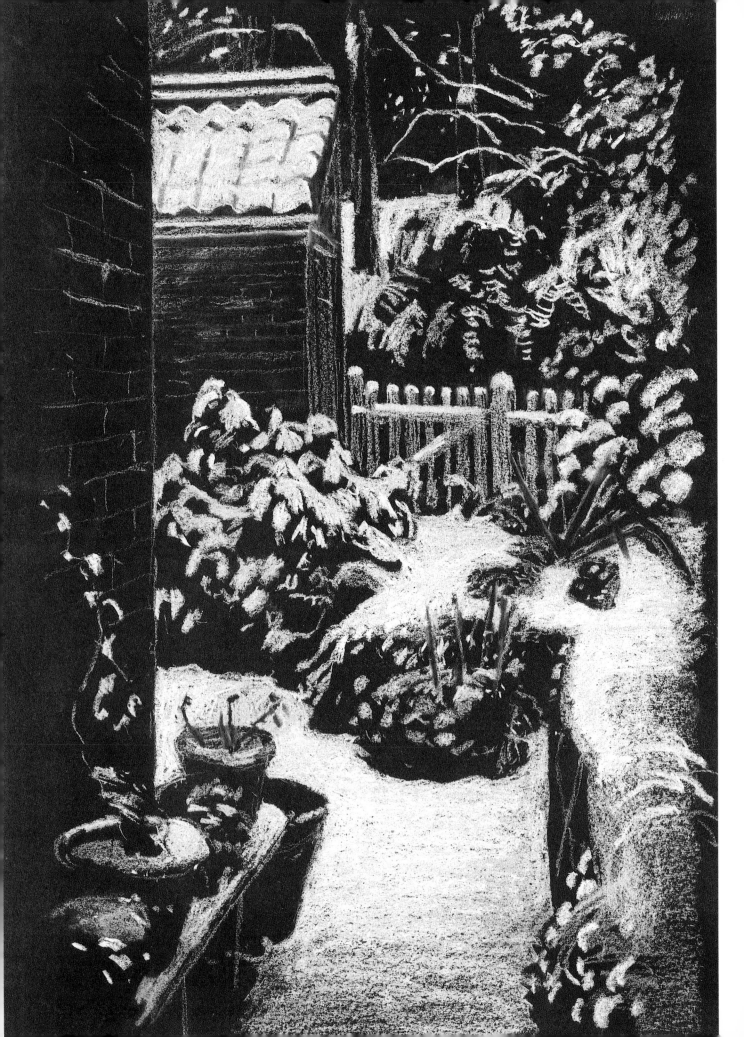

Simple Perspective

lesson 10

Consider a building such as a house or barn. One assumes that the walls will be vertical; that the lower edge of the roof and the ground line of the wall will have been constructed parallel to each other; that the walls will have been made at right angles to one another; and that any doors or windows will be regular shapes within the walls in which they lie. But no building will quite fit this

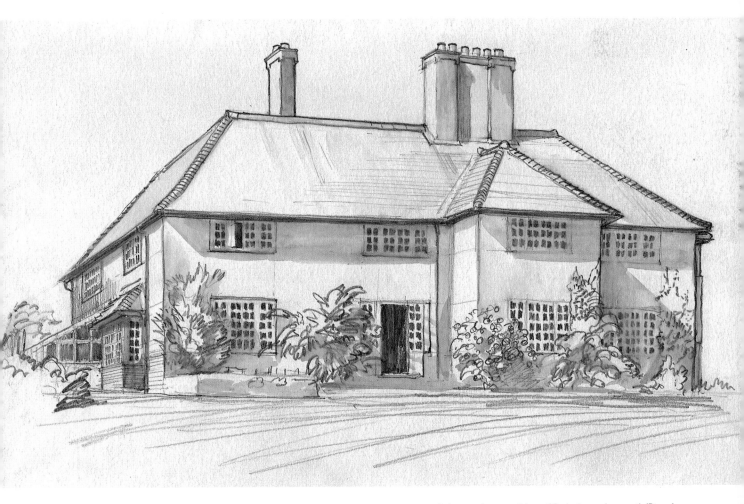

This drawing of a light snowfall was made in about an hour and a quarter (left), using 2B white conté stick on a dark-grey paper. It was important to maintain about four tones: totally untouched paper, roughly two tones of gentle shading, and a full, near solid white. Towards the end of the drawing a thaw had set in, with the smaller patches disappearing very quickly

A house drawn with an 8B dark-wash pencil (Rexel Cumberland's Derwent Sketching). Some shading was applied, and clean water used to produce a wash from the dissolved lines for shadow tones

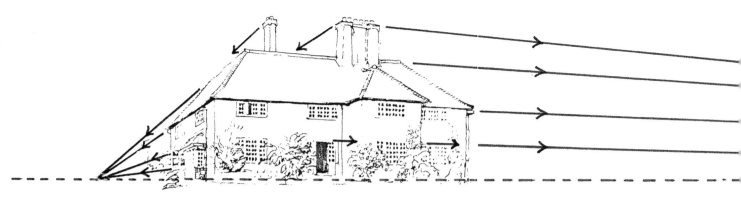

The same house with the perspectives indicated. Notice how those lines travelling to the right will meet on the horizon (the dotted line) on the far right, i.e. off the page. Rarely do both the vanishing points of a rectangular object appear in the area covered by a drawing

description. If it is viewed from one corner with two walls receding, the parts which might be thought to be parallel will not appear to be so. The roof apex, gutter line and ground line will seem to converge, so much so that if one were to follow these lines, they would meet on a far-distant horizon. This effect is called perspective. It is a word hated by a lot of young artists, who believe that freedom of expression will make up for any inadequacies in their drawing ability. Well, they may be right, but I feel that a reasonable knowledge of perspective brings freedom of choice and understanding, and not, as is sometimes thought, an obsession with detail.

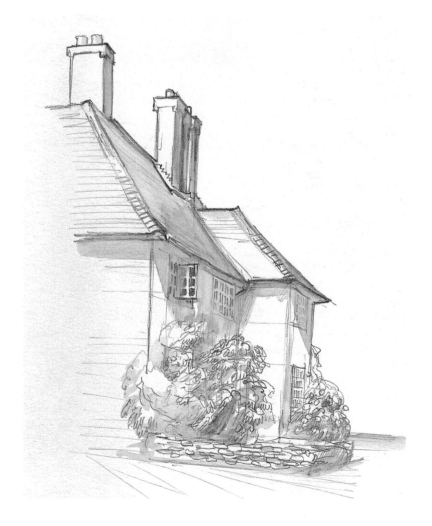

A different view of the house. Notice how the gutter line now drops strongly to the right

Compared with the drawing opposite, the angle of the top of the chimney now drops steeply to the left

Make two drawings of a building from different vantage points. If the weather is good, work outside; if not, try the views from a window. Looking up or down at a subject can accentuate its angles.

The rules of perspective apply to anything seen, but the direction of the lines is not so easy to detect on a small scale. The convergence of, say, the two sides of a book may be difficult to observe and to measure, but without the feeling that the lines *will* converge the drawing may seem incorrect. On the other hand, overstating the perspective can be just as unpleasant. One of the

telling things about copying from photographs is that some lenses distort perspective, and such over-emphasis can become particularly obvious.

The chair in lessons 6 and 7 had a logical framework, but a still life can present a more complex arrangement of objects. One 'knows' what each object is. They will have been handled and moved lots of times, but although you may be familiar with them individually, the moment you decide upon the arrangement, all the items become fused together and frozen as if they had never existed apart.

Among the most important aspects of structure are space and volume. When the objects rest on a flat table they are on a little stage. Think of the stage as a place where things have a particular position – some to the front, some to the rear. A poor drawing can result when too little thought is given to the exact size of the spaces in between. In a similar way, the height of the objects will vary. The table is a surface which, if it's being looked down on, will recede as a plane towards your horizon. This creates an absolute for

When the large and small bottles stand side by side, their tops do not line up

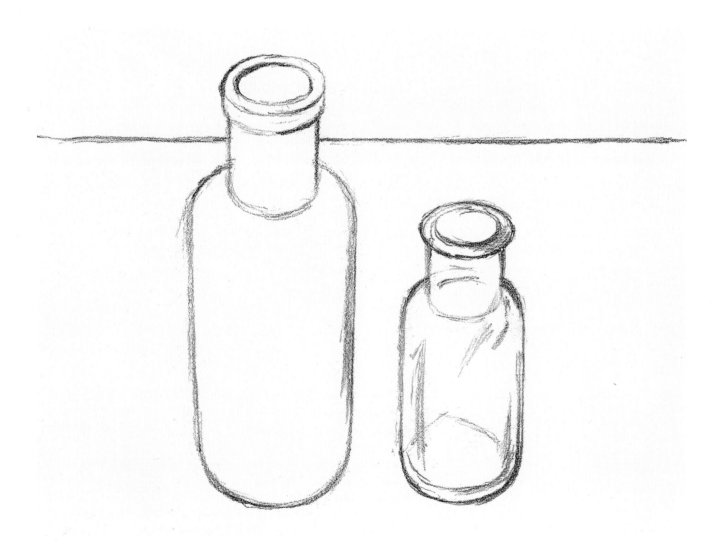

the objects, while their heights will be relative to one another. If a small bottle and a large one stand side by side, there will be space above the smaller bottle until one comes to its taller neighbour. But if the smaller bottle stands to the back of the group, the two tops may now be in line. So the knowledge that one is taller and one shorter has to be overridden by the observation that it is the position of their bases on the stage which defines their differences.

When the smaller bottle is standing further back, the tops *do* line up

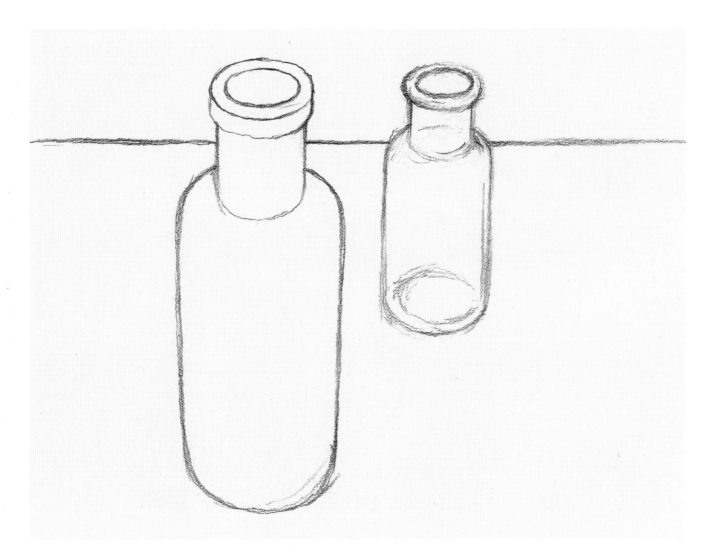

If two apples are part of a group, their roundish outline will be quickly understood. They will stand on the stage, touching it only at the point of contact, but their round outline will have a volume, which comes forward as well as going backwards. If the two apples stand side by side, parallel to the observer's eyes, they will just touch, but if one is behind the other, half-hidden, then considerably more care may be required in their observation. Unless their structure, in this case a slightly wobbly sphere, is considered, and the space between their standing points on the stage shrewdly observed, it is quite possible to draw them in such a way that the volume of the first apple is interrupted when the second apple starts.

Two apples with their sides touching

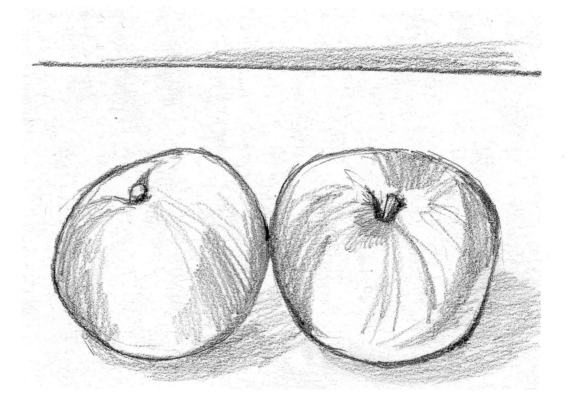

Two apples overlapping

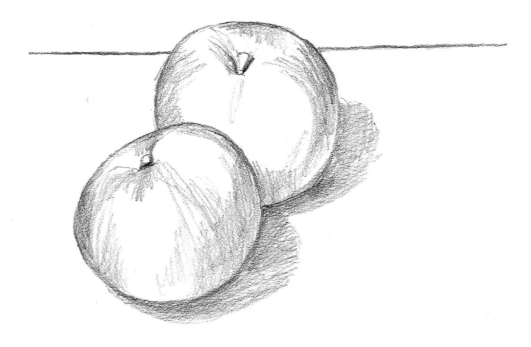

Here the apples are
poorly drawn, giving the
impression that there is
no space between the
objects

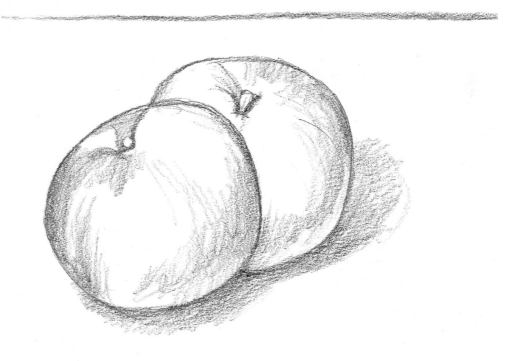

This situation can also occur if the table is set against a wall. The edge of the table will make a clear line, and it will be necessary to establish its angle in relation to the artist's viewpoint. It is easy to place an object such as an apple, and to draw it quite convincingly, and yet, because the spot where it touches the table was not correctly related to the wall, make the apple look as if someone had cut off the back half in order to fit it in (see the examples below).

An apple against a wall

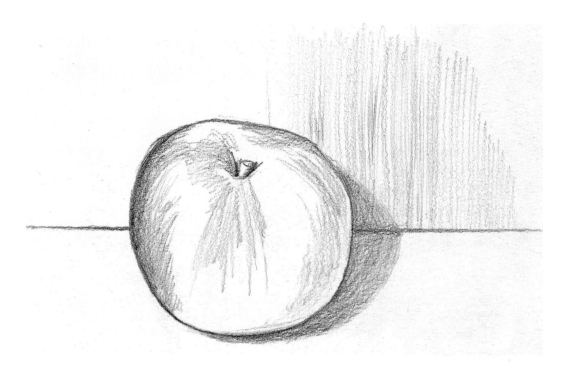

A poorly drawn version of the study above. Here there is not enough space to get the volume of the apple in before the wall starts

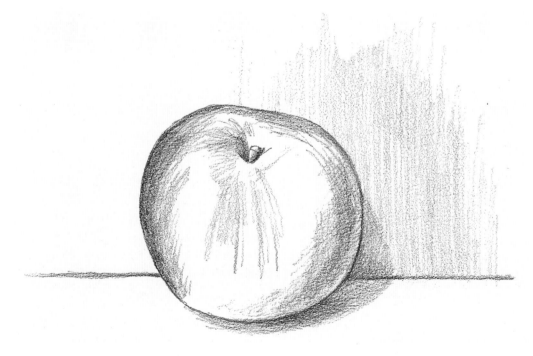

lesson 11 # Still Life

Make a drawing of a simple still life, like the one here. When required to assess the merits of new students, I always ask them to draw from a still-life group. I look to see how they select what they choose to draw and how they describe the structure of both the solids and the space involved. Whoever sets up a still life intending to draw it should be aware of the need to present a logical arrangement. This might sound a very stuffy and limiting remark, as if you are not allowed to do anything wild or unusual, but I would suggest that it is the drawing itself which has the power to be original, while the subject has a factual existence relating to its nature and uses. When placing objects, you should take into consideration how they might come together under normal conditions.

Step 1: A very pale indication of how all the shapes fit together

Step 2: First steps in creating areas of light and shadow

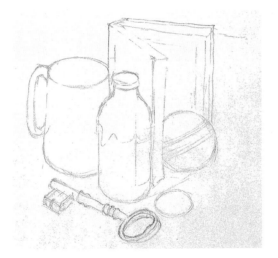 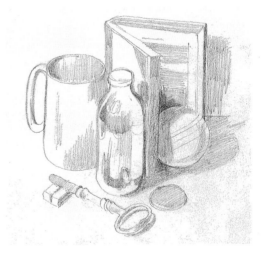

The artist, and subsequently the observer of the drawing, will subconsciously take for granted a whole collection of absolutes by which judgements and decisions will be made. For example, it will be assumed that a floor is flat and lies in a horizontal plane. Walls have vertical planes which meet floors at right angles. A table has a flat top and the surface lies parallel to the plane of the floor. A mug will have a flat base and stand on the table surface, as will any other object. In a jumble of objects, some might not be on their normal base but on one side, while others might be piled on top. A cloth might be used to add a different textural quality to a group. Folds or creases will remain, even when the cloth is spread on the table, but the basic surface of the table is understood, though maybe not

Step 3: The tone is built up by cross-hatching with the 2B pencil, worked round and round the whole drawing

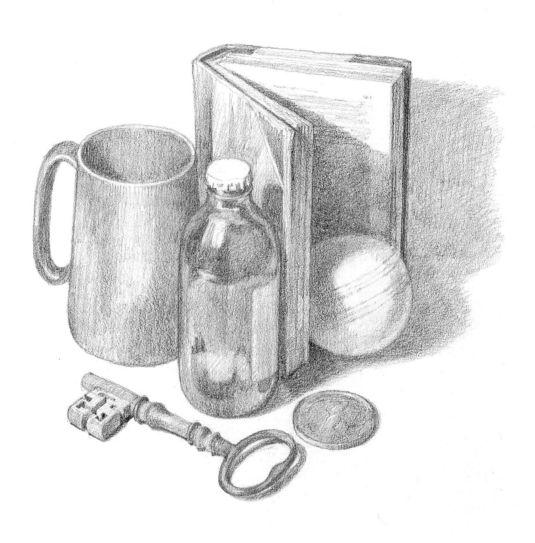

seen. Likewise, the nature of the cloth is also understood – both in itself and in the way in which it is controlled by the table underneath. Take the table away and the cloth will not remain in the same stretched-out position.

Arranging a group from which to draw is not nearly as easy as one might think. If you suddenly see a bowl full of fruit which to you looks good, draw it exactly as it is. Touch nothing – let the chance positions remain. But in many cases this is not practical. A still life with fruit often gets eaten. I once set up several large groups with loaves of bread. Work progressed, and more than one class worked from the arrangements, until some weeks later it was time to dismantle them. As I picked up the loaves I was surprised how light they seemed; I turned one over and it was totally hollow. All the loaves were hollow! My first class had, unbeknown to me, scooped out all the soft new bread and carefully replaced the loaves on their marked places. The ingenuity of the young! I digress.

One tries, therefore, to make an arrangement look

interesting, often turning, changing, or propping something up with another object hidden underneath. The cloth could be folded and draped, and all sorts of balancing acts contemplated. But the observer of a completed drawing is most unlikely to be aware of all the proppings and tiltings, and drawings can sometimes have a strange quality about them which people cannot quite understand. It might therefore help to have some guidelines in the selection and setting up of objects for a still life.

Choose items which have clear, simple shapes, in a single plain colour. Multi-coloured or variegated surfaces can be more difficult to draw; for example, lettering should be avoided. Consider the tonal value of the objects rather than the colour itself, for in a monochrome drawing there will be no colour, and a mixture of tonal contrasts may help liven the composition. The texture, e.g. wood, glass, metal, velvet, etc., may be quite difficult to imply in a drawing. Lighting is the best way to show up the form. Decide what constitutes the main focus of the group, and allow this to dominate the arrangement. Do not try to make the placing symmetrical; asymmetry will look more relaxed and natural.

The so-called Golden Section was a set of proportions which was thought to have a special harmonic relationship. It was defined as a line divided in such a way that the smaller part is to the larger what the larger is to the whole. In a rectangle these two divisions produce a 'classic' asymmetrical focus at their crossing point.

If an object is cylindrical, let its base be seen, or at least enough of it to show that the standing area is a circle. Do not obscure the top of a circular object; for example, if the base of a

The Golden Section. In this rectangle the lines AB and AC are in a ratio of 2:3. The Golden Section divides the area roughly in a ratio of 5:8, as represented by the lines EF and DG

bottle is masked and its top hidden, it may look like a flat cut-out. For the same reason, place rectangular objects so that at least two sides and preferably three, including the top, are seen, as well as at least part of the contact area. Again, this is simply to make the structure of the object readily interpretable. The drawing will then have a better chance of reading well, that is, of being clear and understandable. Do not place things on a wavy, bumpy or sloping surface unless there is a very good reason to do so. Try to keep the 'stage plan' clear and simple.

By all means be enthusiastic about the objects, or any subject you draw, but do not let your emotions get in the way of your detached analysis of the shapes, the structure and the whole arrangement. Curiously, if all these rather cold-blooded considerations are taken into account by the artist, they will result in a natural-looking drawing.

Chapter Five

light and mood

In drawing there is a strong emphasis on the subject matter, and objects seem to own the lines that create them. In contrast, the painter can use colours that may evoke different qualities of light. In drawing, however, the shape comes first, while dark or light tones are often something of an additional thought. Yet if they are taken into consideration, a whole realm of description is opened up. Mood and atmosphere result, and the vague, the indefinite, becomes important.

When learning to draw it is quite natural to follow an exercise set by a teacher. The results can be excellent, but it is easy to forget the lessons learnt when confronted by an exciting new subject, or when out in the countryside. I must say I do wince a little when I see advertisements for courses in which drawing is made 'easy'. It certainly isn't easy to put together all the good advice when making a drawing. In Chapter 2 I suggested an excercise in which pieces of black and white card are put against the light. Some readers may not have understood the point of this. But when you are out in a field, looking at a white house, with some dark trees and a vigorous sky creating shadows on the ground, you will see its relevance. The eye and brain are so sensitive and so aware of the nature of objects that it is not an easy task to think tonally. For this reason I want to suggest that you look at shadows in a rather different way.

A street in Florence. The feeling of strong sunlight is created by the dark tones of the buildings and shadows

LA NAZIONE

Michael Wood 18.8.90
Borgo San Frediano by the
Piazza Del Carmine

lesson 12 # Light

Select a corner by a window in daylight. Everything in the room can be easily
seen, but the light coming through the window will make some parts of the room
and furniture brighter. Normally one would refer to the rest of the room as being
in shadow; certainly, the area under a chair would be described so. Instead, think
of the whole room as lit, with the sunlight through the window making some
parts super-lit. So instead of seeing shadows as something added, we can now
think of strong light as adding extra-light areas.

Using a dark paper (grey, brown or black), make a drawing in
white chalk or conté, concentrating on the areas receiving the most
light. Those out of the strong light can remain virtually untouched.
In the less strongly lit areas, in what we now consider to be
'normal' lighting, walls and floor will almost merge. Half-close
your eyes when considering these values, for it will help you
achieve a true tonal assessment, rather than what you 'know' is
there. A white wall, for example, will not be white everywhere, if
white appears as a tonal value at all.

Step 1: The first stage of the drawing seen on p. 84.

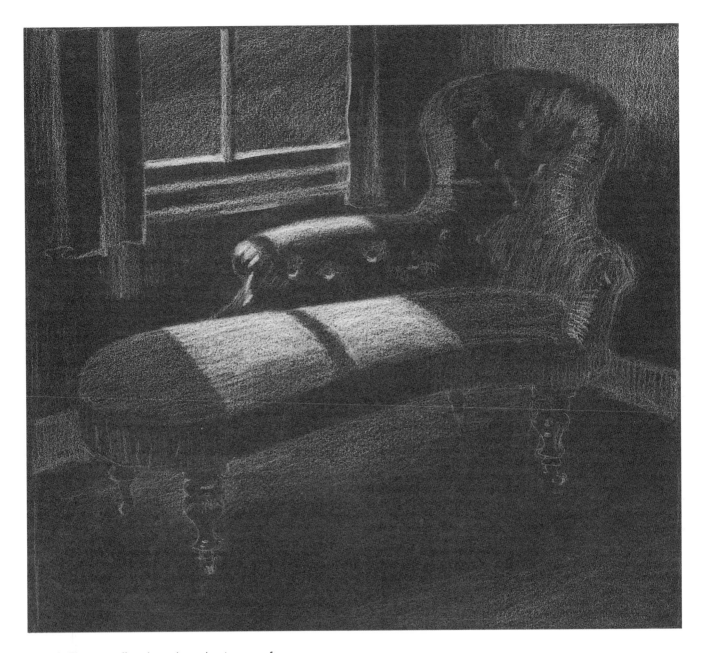

Step 2: The main effect depends on the six areas of strong light. All else is shaded very gently. An eraser can be used to soften any marks applied too strongly

Light and shade at
Sheringham Park,
Norfolk.
Pen with water-
soluble ink and
wetting

In a landscape or townscape there may be opportunities to
observe good tonal conditions. Bright sunlight will create the
strongest effects. Bridges and archways may be good subjects,
together with narrow lanes, an overhanging tree or buildings with
large open doors. All these may produce a composition in which
some parts are able to be seen and understood adequately, while
others will be super-lit in strong sunlight. Sunlight is so strong that
it invariably dominates most surfaces and colours. It is less
important to consider what is painted black or white than to think
of where the super-lit areas are, and in the drawing this segregation
should be all-important.

In the case of a town scene we will have a total awareness of
the buildings and other objects. We know what a house is, what a
bridge is. We also know that the things we call shadows will change
– they come and go, and in some ways do not exist at all. Yet for

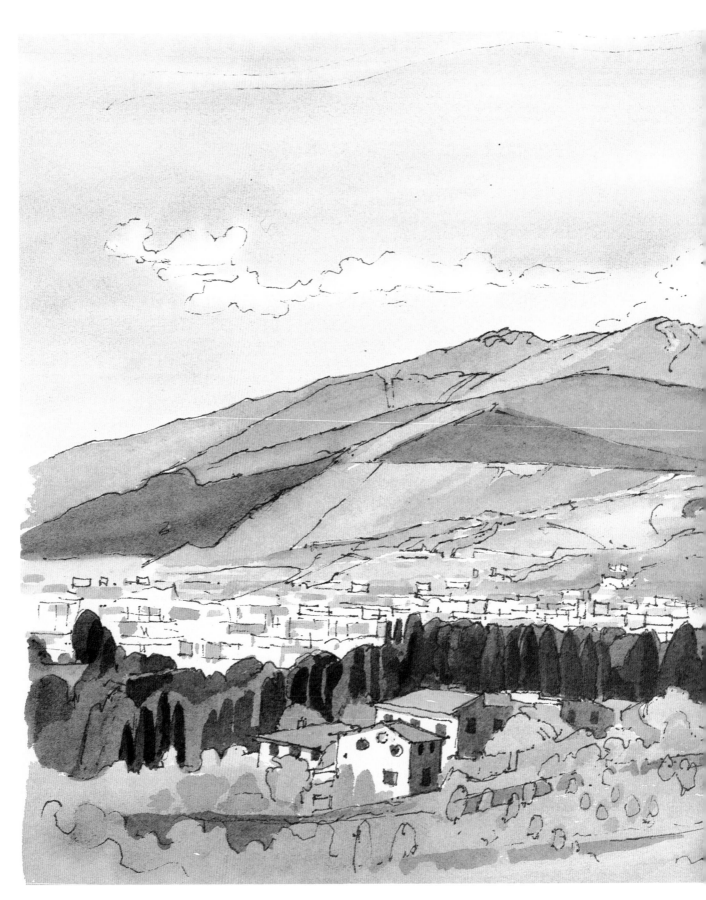

View across Florence.
Pen and watercolour wash indicate structure and tones

the artist this shadow is absolutely crucial; it is part of the object. It is fused in a tonal link which not only describes the surfaces of walls and roads, but makes the definition of space so much more vital. So while we may think of the structural nature of bricks and mortar, and notice that there is a light area here and a dark area there, we must also be aware of these areas as places where dark and light may fuse objects together. Drawing is largely the result of the artist's ability to perceive. Our understanding is constantly being jolted to the point where it is as if we had never seen a house before.

In an art gallery or exhibition, the images that particularly attract us are likely to be those in which an overriding, clear and powerful observation holds the whole thing together. Technique has always been a subject of debate among artists: tight or loose, bold or sensitive, large or small. Each generation goes through its agony of acceptance or dismissal. But for me the mastery of tone is more important than anything else, for it dictates the way in which shapes and areas are presented through the eyes of the artist.

In landscape there are simply masses of textures – bricks, leaves, stones, fences – all demanding attention. Imagine that you are looking at some distant hills, perhaps five miles away. Variations will be minimal, yet the actual hills may be covered with trees, hedges and even animals. However, at this distance the whole landscape is simplified and may be drawn equally simply, as a flattish area of pale tonal shading. It is unlikely that anyone would fret over not being able to draw each separate sheep at a range of five miles, but come closer to the subject and the facts become more discernible. There is always a temptation to 'put in' the details because you know them to be there. This is where decisions have to be taken and economical use made of the smaller textures.

If you are drawing with a material like charcoal or conté stick, the tonal statements of large areas may be simple to place, but fine textures may have to be omitted. The size of the mark or line that each instrument makes will in turn be related to the overall size of the drawing. As the sheet of paper gets bigger, so the different parts of the drawing can get bigger. The marks made, therefore, get proportionately smaller. However, the interpretation of textures has to be balanced by a consideration of roles in tonal terms. There are no simple answers, no right or wrong, but there is considerable enjoyment in seeing how much can be hinted at or described by the means available.

Take an imaginary wall. The appearance of the wall will be changed several times. The drawing instruments are black ink and pen. First of all, consider the overall proportions of the wall. I would expect a line to define its boundaries (fig. **a**). If the wall is made of red brick there will be clear lines of mortar. At first this

a A wall

b A brick wall

c A dark brick wall with light mortar

d A stone wall

e A brick wall painted white

f A white painted wall made of bricks

g A shaded wall

h A fence made of wooden boards

i A wooden fence creosoted

j A creosoted wooden fence half in shadow

k A brick wall drawn with charcoal

statement seems quite acceptable, but the red bricks are a darker tone while the mortar is light. So fig. **b** is a sort of artistic lie! If we are talking about tonal representation the lines should be light, as in fig. **c**. This may also be acceptable, but now the bricks look rather dark and emphatic, when they may be quite pale. If the wall was built of stone it could be similar to fig. **b**, but the individual blocks would probably be larger (fig. **d**). Because of the large spaces it now looks paler. In fig. **e** the brick wall has been painted white, but in this case the joints would still be clearly seen (fig. **f**). If they were not present, the wall would look as if it were made of flat concrete. However, once the joints are there, the wall no longer looks white! Maybe one has to sacrifice the brick.

If, instead of using representational brick textures, we apply shading, we might produce something like fig. **g**, but would this still look like brick? If the wall were actually wood boarding, would it look any different (fig. **h**)? If it were black, with creosote preserving the wood (fig. **i**), this might be fine until we found that half was in sunlight and half not (fig. **j**). So does the pale section look like dark creosoted boards? There is, of course, no one answer, for, in drawing, some elements must be dominant, while others are sacrificed. If you are using a coarse stick of charcoal, you will find it difficult to make the rectangle the same size as in fig. **k**, let alone create textural subtleties within that area. On the other hand, what worked quite well with the pen on a small scale, could be quite uncomfortable when using charcoal and working on a larger scale.

lesson 13 # Cross-hatching

Pen, as we have seen, can produce tonal areas (page 92). The working surface can be tilted only to about 45°, for the pen nib must flow downwards. Paper should be matt and smooth. Tone is usually obtained by making lots of single lines, which are placed close together. To make the tone darker still, further lines are laid at an angle to the first. Subsequent applications of line are placed in a different direction so that a sort of weave is produced. Various tones are created according to the density of this cross-hatching. The technique is best used in drawings which might be termed 'book-illustration' size, for it is quite mechanical and, if over-enlarged, looks very clumsy.

It is crucial to control the line made by the pen, and the following exercise can be practised to great advantage. The movement will come from the fingers if the marks are very short, say 10 mm (less than ½ in), but over this length the whole arm needs to move, otherwise the lines will curve and become cramped. The control of the resulting tone will then be impaired.

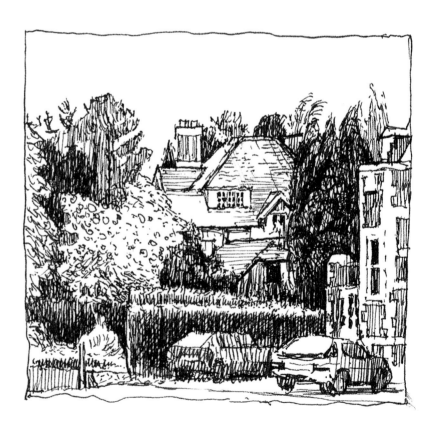

A composition of a corner of Charterhouse in Surrey, showing the many variations of tone that can be made with a pen

All sorts of texture variations can be created by cross-hatching, but they should not be used merely for their own sake. Lack of inhibition, and control of the hand and arm are most important, so practising with a range of samples is no bad thing.

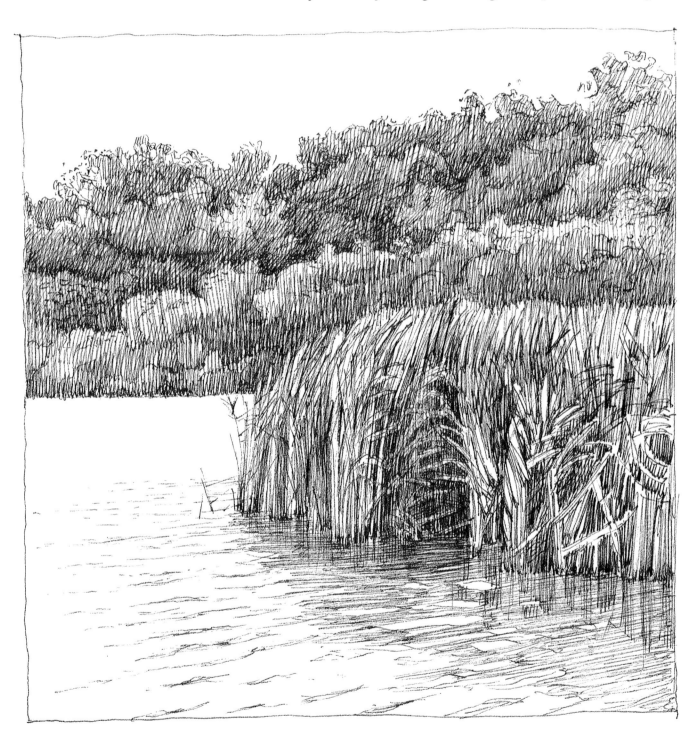

Cross-hatching is used to create variations in tone in this drawing of Barton Broad, Norfolk

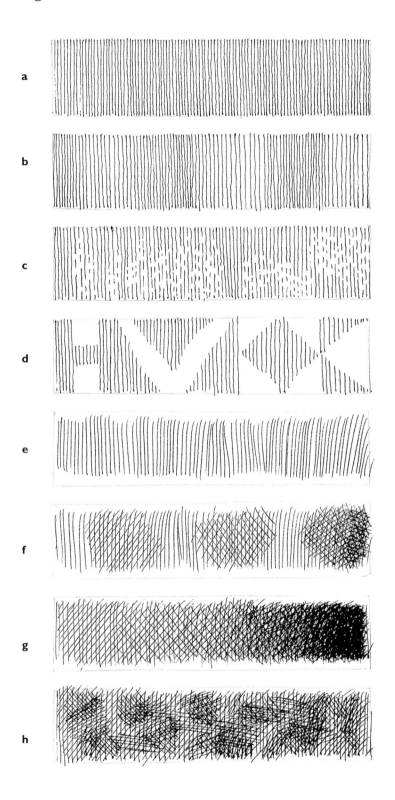
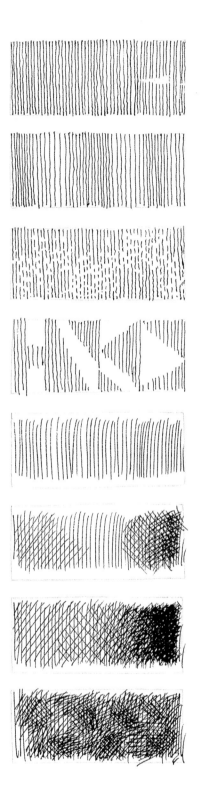

Tones created with the pen

a Even vertical lines
b Vertical lines with variations in spacing
c Vertical broken lines
d Vertical lines creating 'white' areas
e Lines starting and stopping at random
f Patches of cross-hatching
g Tonal gradation by cross-hatching
h Tonal patches from cross-hatching

lesson 14 # Wash

If cross-hatching is a mechanical technique, a wash is quite the opposite. Pen and wash is a lovely combination; the fine, free line, describing forms with great delicacy and simplicity, can be given warmth by the use of diluted ink or watercolour. The wash, as it is termed, is usually paler than the lines. A single batch of watercolour, pre-mixed in a dish, is more controllable than mixing as you go along, but more than one strength can be prepared. As one application dries, a second layer can be washed over (using the same mix) to give a darker tone. The wash can, in working, be softened with water, or lifted off with a brush or cloth (kitchen roll is ideal). A wash gives an added richness of tone to line drawings, and was often used in older architectural drawings to clarify the relief. Nowadays artists frequently use wash in a way that is not limited by line boundaries, making it the link between forms, as described in lesson 12.

Try an experimental set of wash applications, either by redrawing the open cube shown below or using something similar.

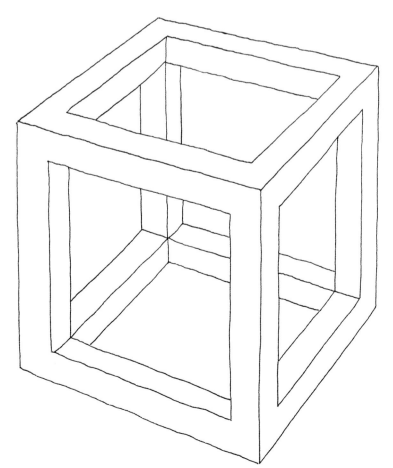

The basic structure of an open cube – a wooden drawing aid. Indian ink was used

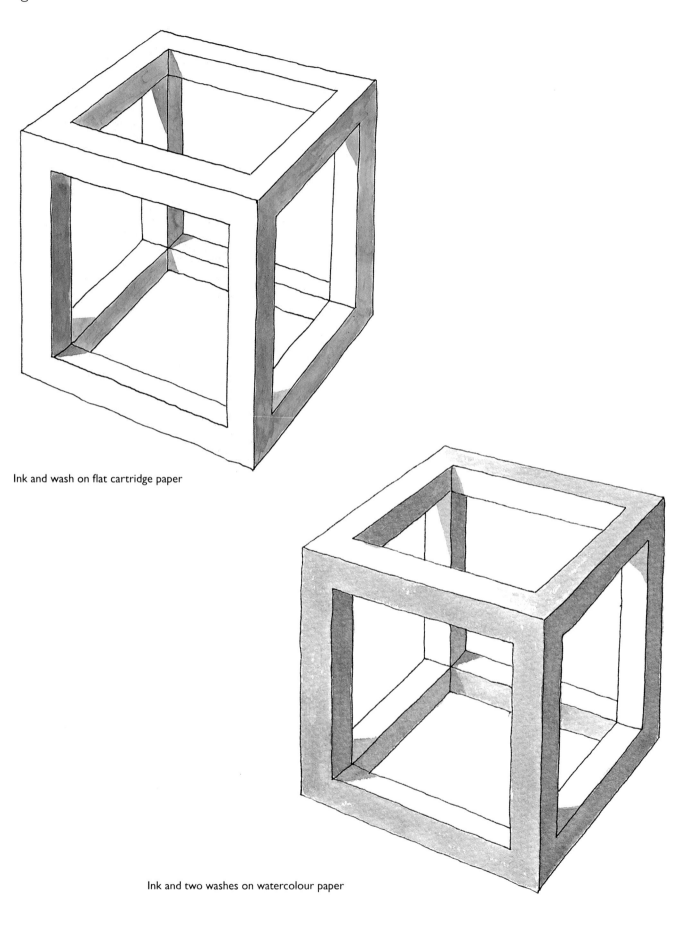

Ink and wash on flat cartridge paper

Ink and two washes on watercolour paper

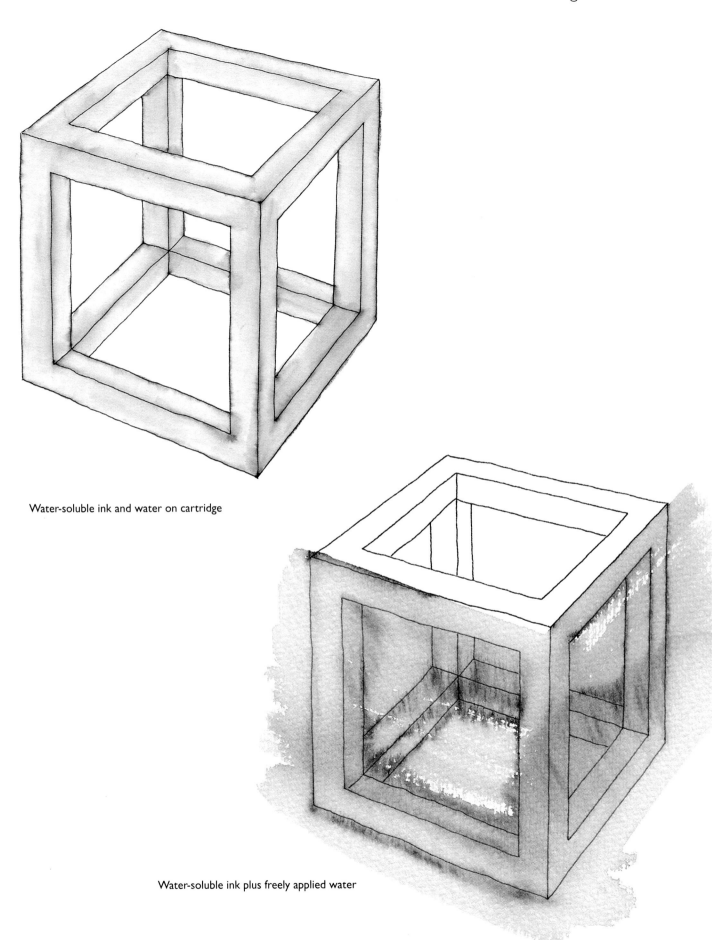

Water-soluble ink and water on cartridge

Water-soluble ink plus freely applied water

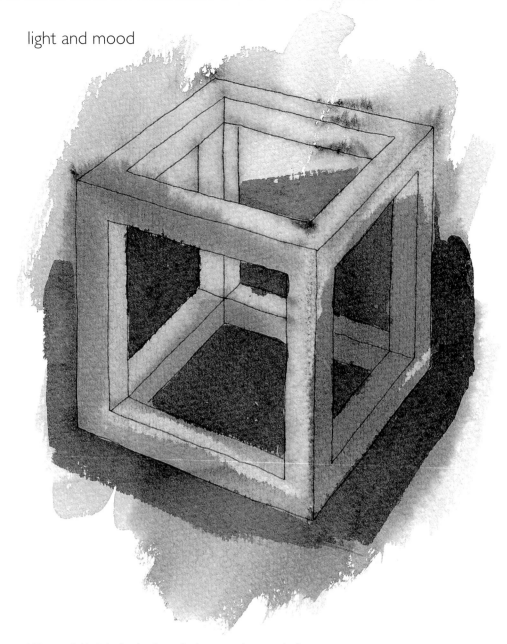

Water-soluble ink plus freely applied water; when nearly dry,
a second wash of watercolour was applied to parts

The church of St Laurence, Ingworth, Norfolk (right).
A fascinating jumble of structures, seen in strong light.
Much of the quality comes from the tonal wash
across the sky, with very little wash on the walls

Richard Woods. August '89 St. Laurence Ingworth.

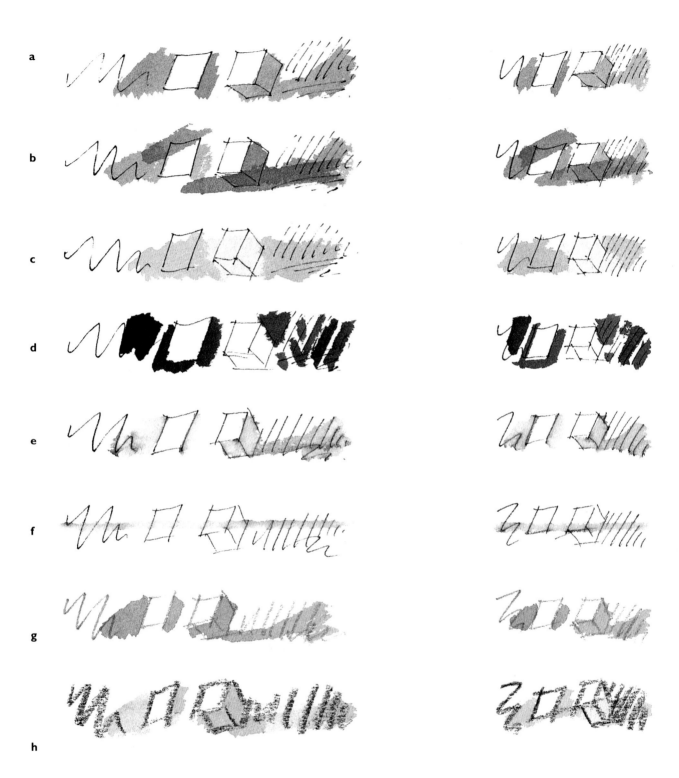

Lines and wash

a Indian ink lines and stick ink
b Indian ink lines and two overlapping washes
c Indian ink lines and a wash that has been partly
 lifted off with an absorbent material

d Indian ink with a strong wash
e Water-soluble ink with water wash
f Water-soluble ink with a line of water drawn
 across
g 3B pencil with stick-ink wash
h Black wax and a light wash

The portico at
Broadlands, Hampshire.
Pen, water-soluble ink
and water

Chapter Six

extending perspective

Just about any view of any subject requires a few moments' quiet thought and consideration before you plunge ahead with a drawing. A number of simple yet vital questions need to be answered. What are you going to draw? How much of the subject are you going to use? What sort of shape will it fit into? Do you need to adjust your viewing position as a result? Once all this has been decided, you will need to establish the angles of the different elements in your drawing.

A number of basic considerations will be necessary to establish perspective. The artist's/observer's horizon is straight ahead. Place any other horizontals above and below, but parallel to it. Verticals will be vertical, but it may be necessary to draw some very faint guidelines or place some dots to show what is the norm and then, by contrast, work out how the site you have to deal with is at variance. In other words, think of a flat desert, then work out how a hill makes a bump on the desert. Similarly, looking down may involve making an excavation in the flat desert.

Rising steps, Norwich

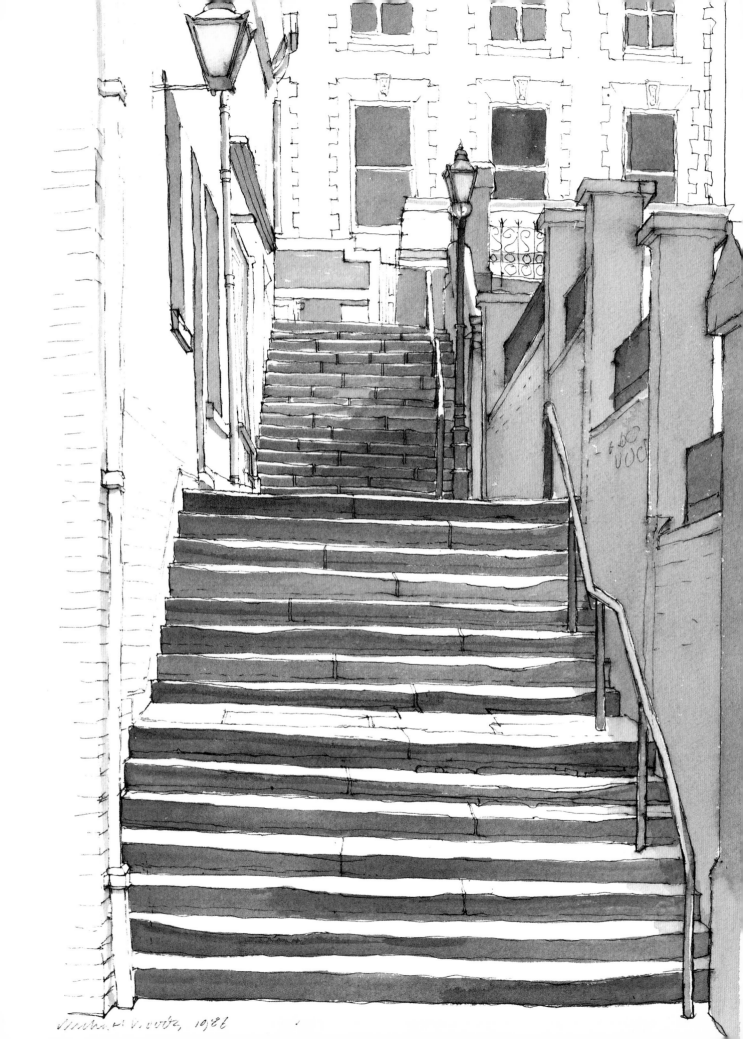

Andrea v. Voobe, 1981

The diagrams on this page show a simple building. In fig. **a** we can see the angle of its ground line and at what point, roughly, it meets the horizon. This is called the vanishing point (VP1 for short). The wall that can be seen travelling away rises to the horizon at VP3. The lower edge of the roof will be above the horizon and descend to the point VP1. The ridge of the roof will also descend to VP1. Now, if just beyond this house a hill starts, the land is no longer flat but tilted, so it will have a new ultimate vanishing point at VP2 (fig. **b**). If a second similar building were standing on the first part of the hill, it would have to be set up

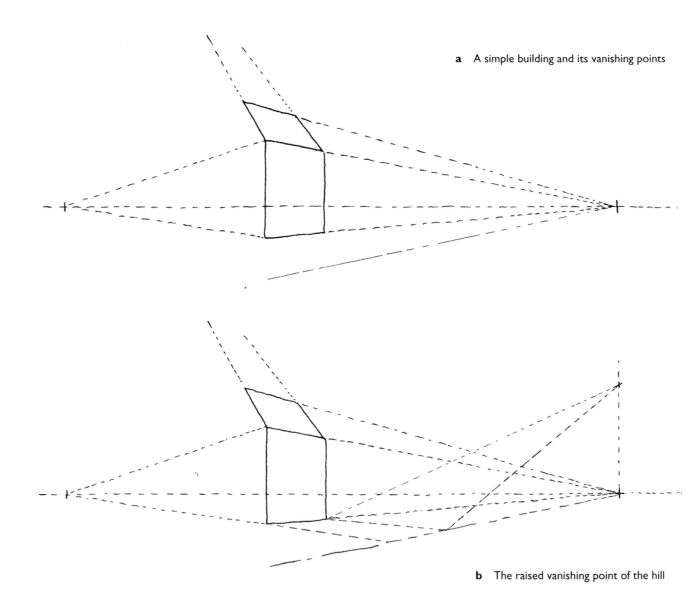

a A simple building and its vanishing points

b The raised vanishing point of the hill

higher than the first so that its floors remained horizontal in their structure, but only at the furthest end would they touch the rising hill. In all other ways, the building would be constructed similarly to the first and the left-hand end wall would have its parts still travelling towards VP3 (fig. **c**).

It can be helpful to consider what happens beyond the area of your chosen subject. If it only confirms the assessments you have already made, no matter, but there just might be a chance that such an exercise will alert you to a directional flaw (fig. **d**).

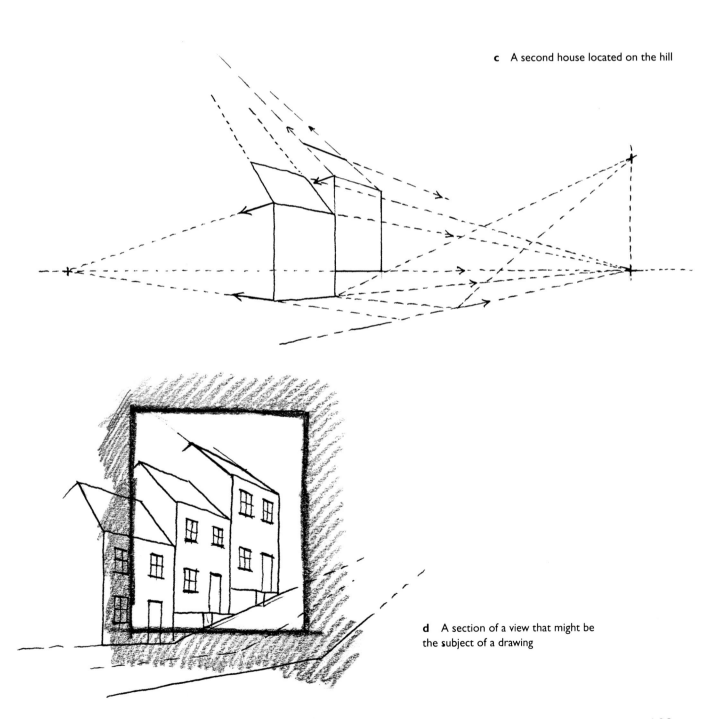

c A second house located on the hill

d A section of a view that might be the subject of a drawing

103

lesson 15 Ascending
Perspective

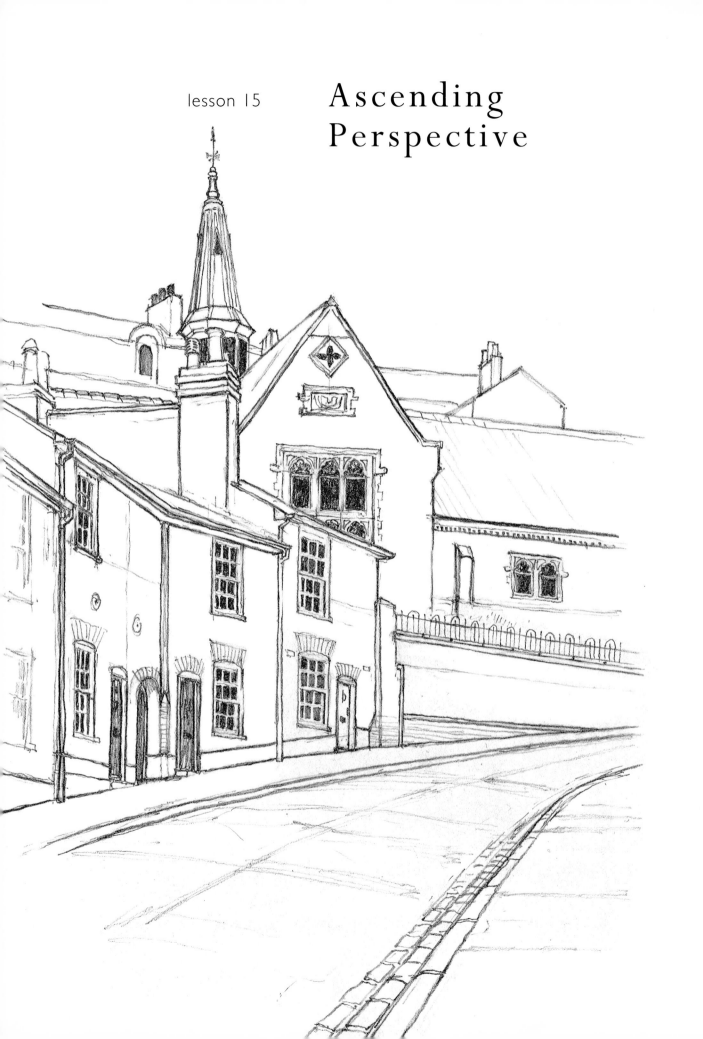

lesson 16

Descending Perspective

The same approach will be necessary when looking down: at a still life on the floor, or downstairs, or down onto a stage, or from a cliff-top. In fact, this viewpoint is more likely to be chosen by the artist because the logistics work better, and you don't get a stiff neck!

A flight of stairs provides a good demonstration of the dual directions of descending perspective. The steps on which you tread will each have lines which converge towards your horizon. But each step will also be placed in a sequence which descends to a lower point directly below the vanishing point on the horizon. The edges of the steps will therefore follow these downward lines.

If these steps are outdoors, say in a park or street, their direction can often be indicated by a comparison with the line of the bricks or stonework of which they are constructed. Generally these are laid horizontally, and provide a valuable norm with which the downward steps can be contrasted. Without any such norm it can be exceedingly difficult to draw the true effect of a road going downhill.

Find some steps and try a drawing from the top looking down. The same perspective considerations will apply to many other extreme views.

Carrow Hill, Norwich
If and when it is possible to find some buildings on a hill, try making a drawing of them seen from below
(left)

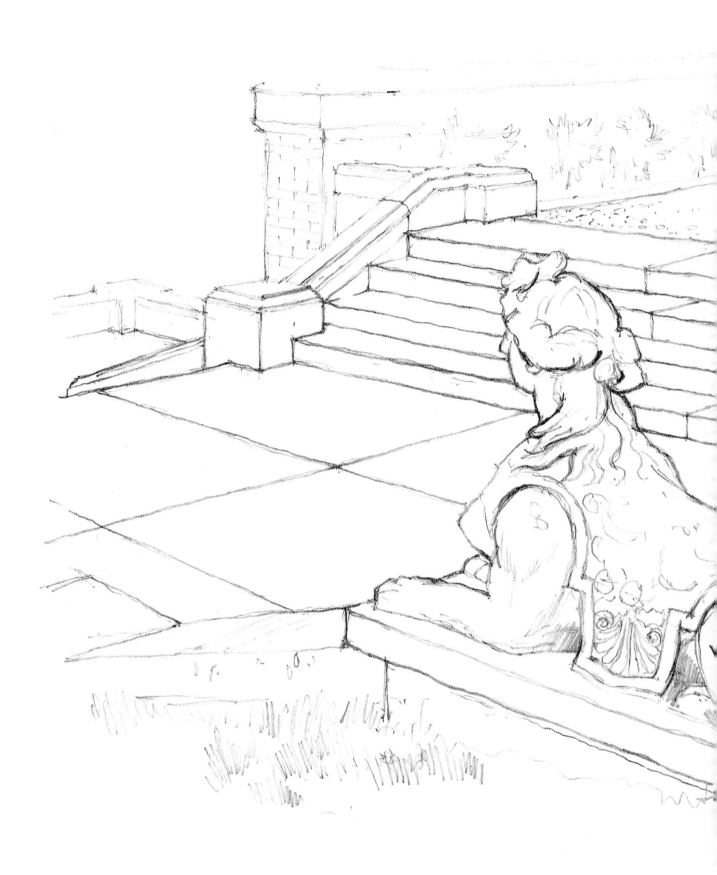

Two groups of steps meeting at right angles in
the grounds of Blickling Hall, Norfolk

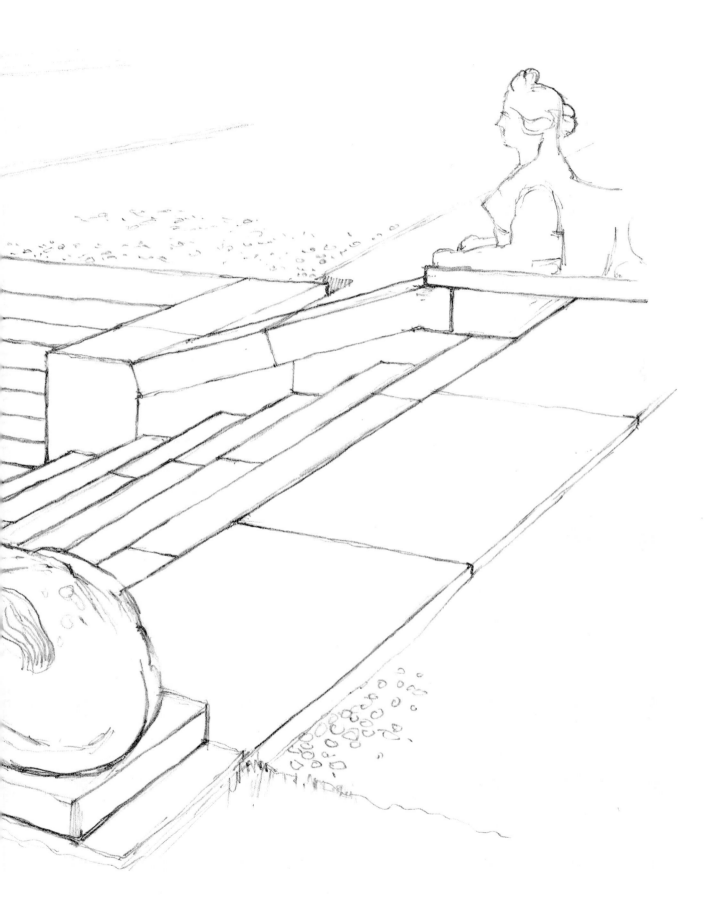

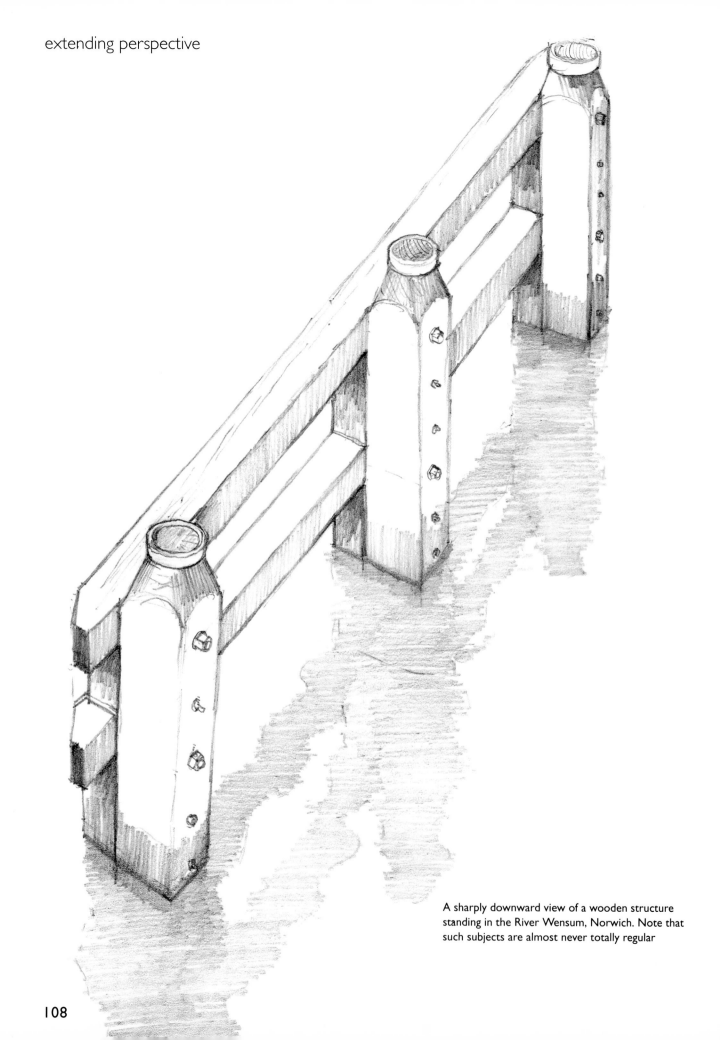

A sharply downward view of a wooden structure standing in the River Wensum, Norwich. Note that such subjects are almost never totally regular

lesson 17 # Circles

To draw a circle freehand on a sheet of paper is not easy, and yours will probably have several kinks. If drawn quickly it may have a smoother shape, but I predict that the starting point and the end will not join up. Yet the shape will still be recognisable, for the circle is a strong symbol that is easily identified.

A slowly drawn circle

A rapidly drawn circle

One of the problems with still lives is that they often contain circular shapes – for example, flower pots, bowls and plates. These are invariably seen obliquely and the circle is thus transformed into an ellipse, which can be very difficult to draw. Students mainly seem to go wrong when drawing the side of a circular object. At a first glance, it seems to end in a point resembling an eye. (Eyes are often incorrectly drawn for the same reason.) In fact, the curve of the shape goes on increasing until, at the very extreme edge, it is travelling vertically for the briefest moment before swinging back round. There is thus no final point.

A clock face

Think of a circle as a clock face and of the minute hand describing its circular path. Seen obliquely, its tip still swings round on a smooth track, but the tilt of the clock face will mean that at six o'clock one is virtually looking at the tip of the hand, while as the tip moves on to seven, eight and nine o'clock one increasingly sees the side of the hand. After nine o'clock the tip moves out of sight.

Select a large circular clock face and make a drawing from one side, paying particular attention to the ellipse. If it is possible to lay the clock on its back, try a drawing of that view, as seen here.

A clock drawn obliquely

Another exercise, or just a way of considering circles seen obliquely, is to think of a square enclosing the circle. The diagonals of the square will cross in the middle. A line halving and another quartering the square will cross at the same middle point. The circle's perimeter must touch the square at the four points marked A in the diagram, while the curvature passing the four points marked B must be kept smooth. On a piece of paper draw a square, then draw the two diagonals and quarter the square. With a compass, describe a circle touching the edge of the square. Lay the diagram flat on a table so that you can take an oblique view of it. Make a drawing of its appearance.

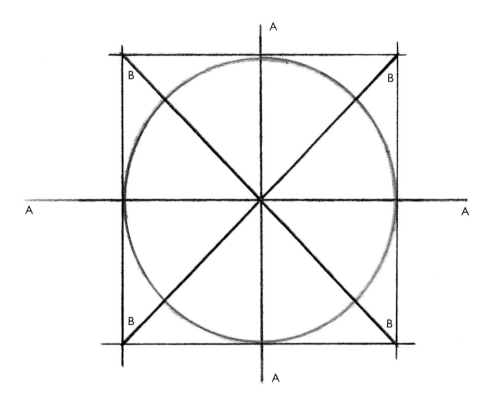

A square enclosing a circle

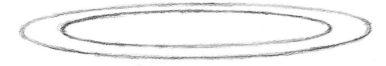

a A flat disc seen obliquely

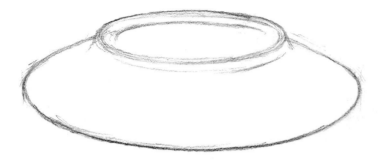

b A saucer upside down, showing a downward-tilting rim

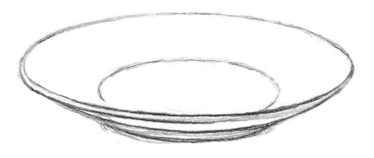

c A saucer with an upward tilt to its rim. Note how this view contrasts with that in the previous drawing

With most circular objects there will also be a thickness to consider. The rim of a pot or plate can be a vital part of its description. Much depends on the angles of the rim, and a close inspection of how the shape is made and of its form may save a lot of time later. If the object is a flat disc (fig. **a**), the sides will appear thicker than the front, while the back will be the slightest shade thinner than the front. If the rim tends to tilt downwards and outwards, the front will appear larger than the sides, while the back will disappear totally (fig. **b**). If the rim tilts downwards and inwards, then the sides may appear rather larger than the back, while the front rim may disappear altogether (fig. **c**). In the case of a plate, even the rim itself has a thickness and this too must be taken into account.

lesson 18 # Volume

Watch out for objects that are circular but have a volume, such as vases, teapots
or even the domes of buildings. It is easy to assume that the profile of the shape
is the very edge of the object, as if it were a two-dimensional silhouette. Although
for part of the shape the profile is at the very left or right of the form, elsewhere
and according to the view there could well be shapes which are seen beyond this
halfway point.

Select a teapot or a covered sugar bowl, similar to that shown here.
Cut a very thin strip of sticky tape – if possible no more than 2 mm
(1/10 in). Stick it up the middle of the handle, across the lid, over the
spout and down to the foot again, cutting the teapot in half. Make a
drawing, paying particular attention to that part of the shape that
can be observed *beyond* the taped line. The profile will not coincide
with the tape. The drawings overleaf show two architectural
examples of circular shapes.

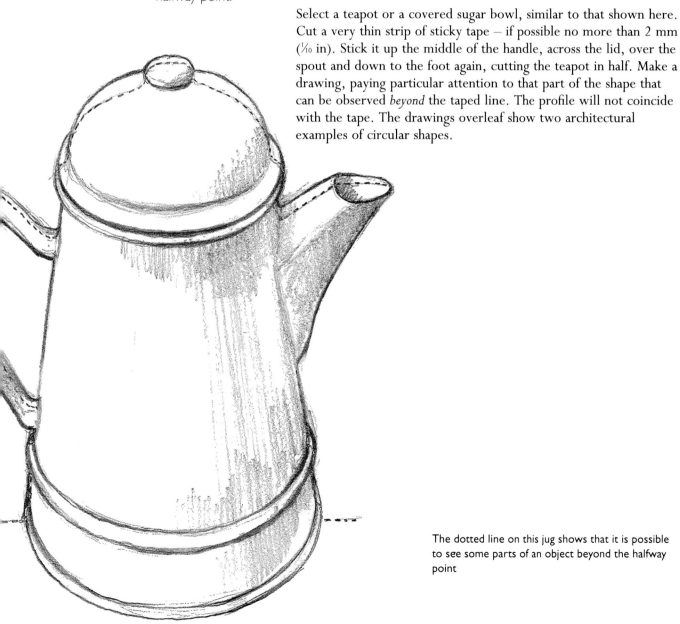

The dotted line on this jug shows that it is possible
to see some parts of an object beyond the halfway
point

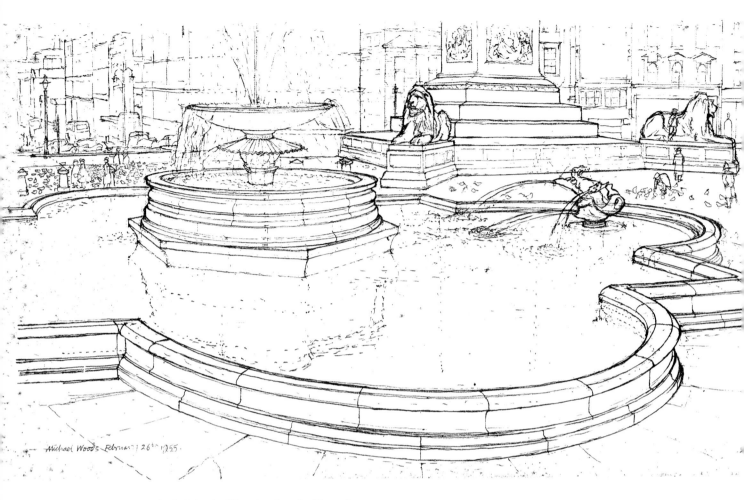

As a student at the Slade School of Fine Art, I made this study
of the fountains in Trafalgar Square. I selected it to be a taxing
exercise – which it was!

Pillars in the Church of St Bartholomew the Great,
London, showing the thickness of circular shapes
(right)

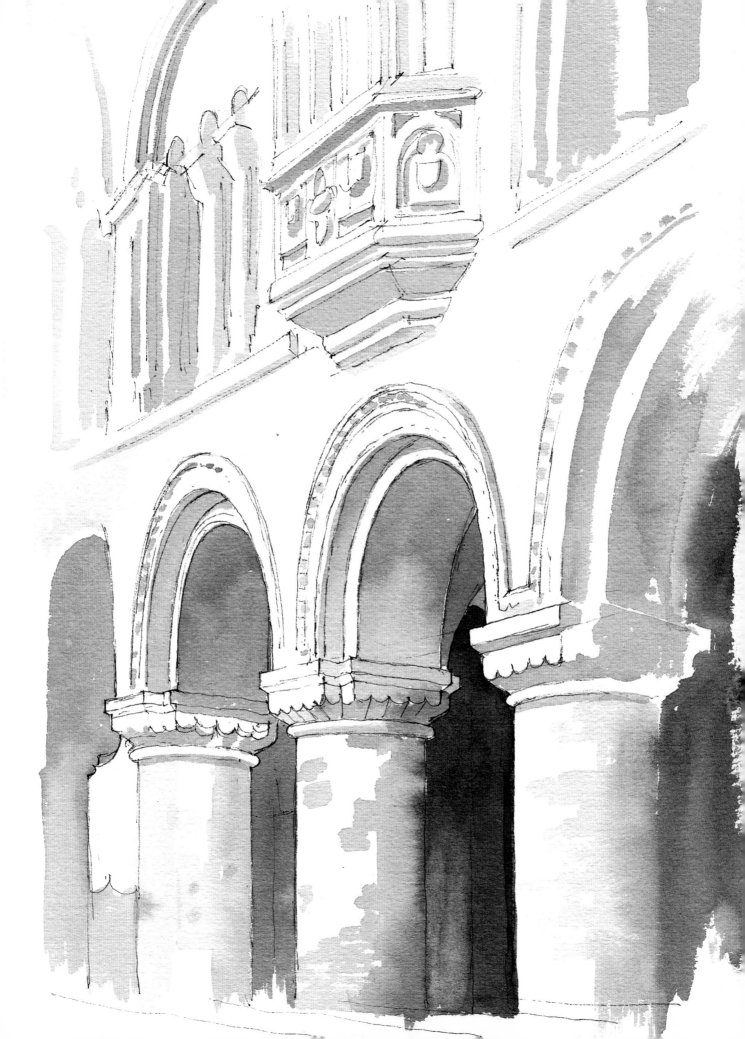

Shadows

In drawing, all qualities are linked together in one way or another. Perspective is a technical form of observation, and your observation of dark and light areas will be enhanced if you think a little about how they are created. There are two main sources of light: it may come from the sun, or be man-made. In the latter case, the distances involved have to be small and, because of the relatively small size of the source (e.g. an electric-light bulb), an arc of light will result, and intervening objects will create enlarged shadows.

For this reason, artists usually find it easier to use sunlight with its parallel rays of light (parallel because the distances are so huge). The sun does not always shine clearly, so any experiment will have to wait until the conditions are right for you. Cover a table with a plain white sheet of paper. Obtain some small balls, such as golf or tennis balls, and one or two small boxes. If possible, use a cube, a match box, a cylinder in the form of a food can, and an irregular object like a stone or twig. One by one, place them on the surface in strong sunlight and make a drawing of each object and its cast shadow.

The shadow of this cube lit by a torch has a fan-like shape. Drawn with charcoal

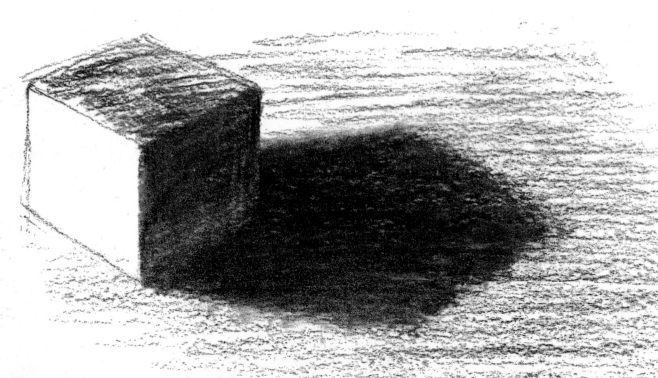

If shadows or areas of strong light are combined with sloping surfaces, some quite unexpected results can occur. Gable ends and chimneys must be given close attention in relation to roof surfaces.

In the studio, the spotlight on a still life can create great dramatic effect. On the darker side of objects there will be reflected light, for instance, light coming off the table surface. The effect can be beautiful, for it qualifies dark areas, while the glow of reflection

A cube lit by the sun

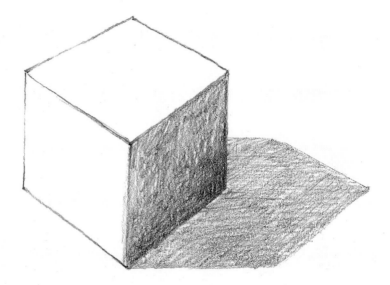

The directional lines creating the shadow

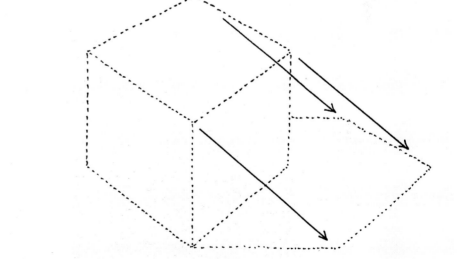

A small cylinder (an
upturned tea cup) lit by
the sun

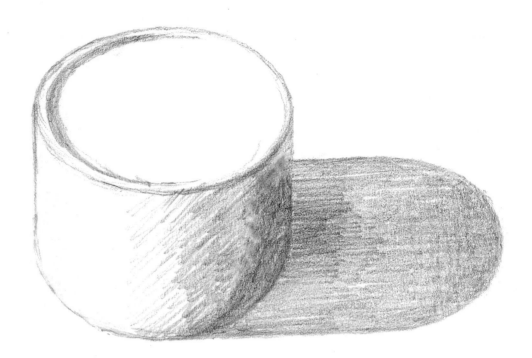

The directional lines
creating the shadow. It
is useful to think of the
shadow as an area
prevented by the shape
from being 'super-lit'

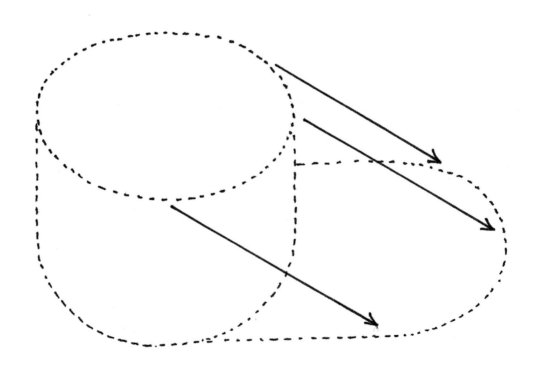

can model shapes very sympathetically. While artists usually observe these effects quite well, they frequently fall into a tonal trap, assessing the highlights at too bright a pitch. Although such highlights are lighter than the neighbouring shadow areas, they still lie on the dark side. So take care: the tonal value of reflected light will often be darker than you would first think. Half-close your eyes, or use two pairs of sunglasses when studying the subject.

A shell and its shadow in sunlight

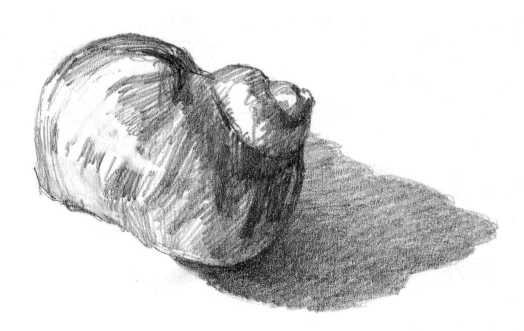

The directional lines of the shadowed area. A shadow can sometimes help describe the object itself

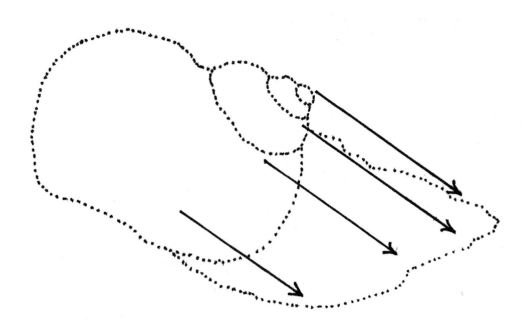

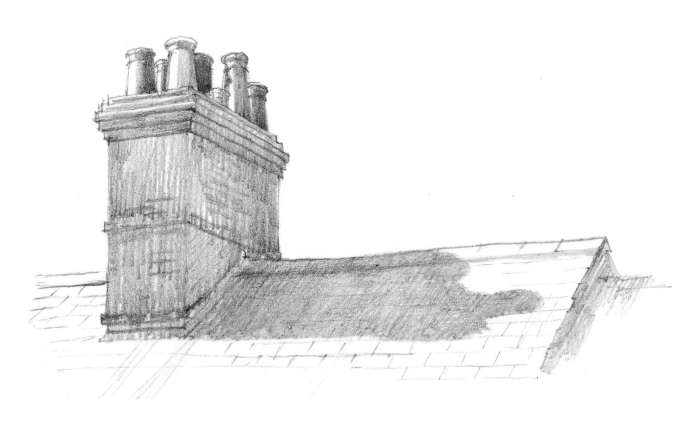

The shadow of a chimney falling on a sloping roof

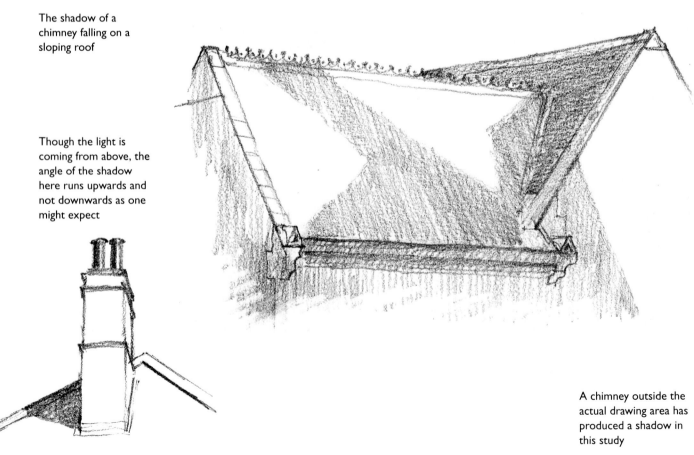

Though the light is coming from above, the angle of the shadow here runs upwards and not downwards as one might expect

A chimney outside the actual drawing area has produced a shadow in this study

lesson 20 Mirror Reflections

Shadows and reflections seem to go together, although they are formed in very different ways. I have seen more than one potentially good picture spoilt by a poor understanding of how reflections work. If you put a blot of ink on a piece of paper and fold the paper in two, the double blob which will be revealed when you unfold it is not the same as a reflection. The words 'duplicate' or 'mirror image' do not help either, for they describe only a condition and not the shapes that are involved, or the importance of perspective.

The simplest way of observing reflections is with a mirror, preferably one without a framed edge (a mirror tile is useful). Place it on a table, and look down on it at a 45° angle. Put a small shell on the mirror, with the hollow uppermost. You will be able to see much of the interior of the shell but only a little of the outside. However, in the mirror, you will see quite a lot of the outside of the shell, while nothing of the inside will be seen at all. There is thus no repeat of information; one shell is reversed below the other, the reflection providing different information about the object.

A blot of ink created by folding the paper

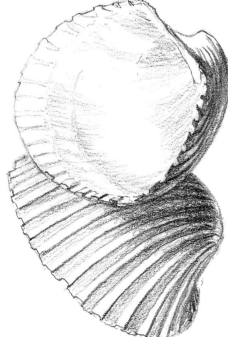

A shell and its reflection.
They are very clearly
not identical

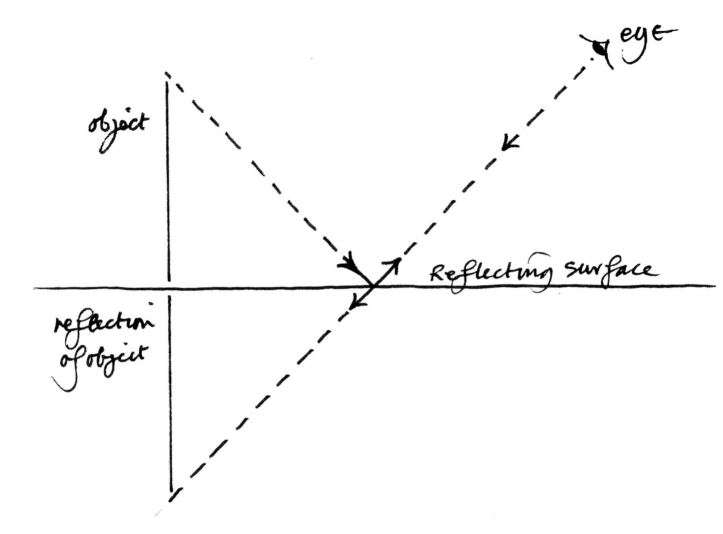

The system of reflections

If you observe an object from a long distance over incredibly still water, and you are very close to the water's surface, it may be possible to see the object duplicated almost exactly. However, the angle of your line of vision in relation to the reflecting surface will control the form the reflection takes. In most cases this angle is enough to change the information the reflection gives us. What happens is that the image hits the surface and the reflection bounces up at exactly the same angle. Thus when our eye receives it, it appears to have come in a straight line from below the original object.

If you stand a simple box on the mirror it will again be reflected. The vertical lines will continue downwards while all the horizontal lines, in both the object and the reflection, will converge to common vanishing points. In fact, there will be a tendency for the so-called vertical lines to taper, for these, too, will converge as they travel downwards and away from the observer.

A box reflected in a mirror lying on a table. Notice how the thickness of the glass separates the two parts

lesson 21 # Landscape Reflections

Mirror reflections are not too difficult. The angles and shapes should be clearly seen and can be judged relatively easily. In the landscape, conditions are more complex, for the main reflective surface is rarely still. The slightest movement will break any reflected image into a myriad of pieces, and the resultant shapes and tones may come from many directions. You may also find that huge hills have no reflection in a lake at their foot, if they are a long way back from the water's edge. (See below.)

When you are next by a river with a bridge, make a drawing of the bridge and its reflection.

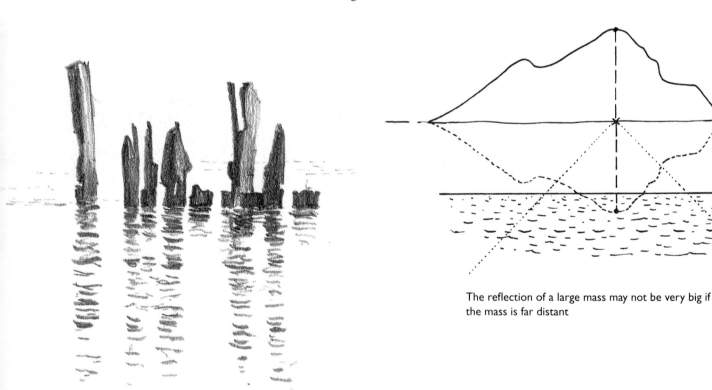

Some old groynes and their broken reflections

The reflection of a large mass may not be very big if the mass is far distant

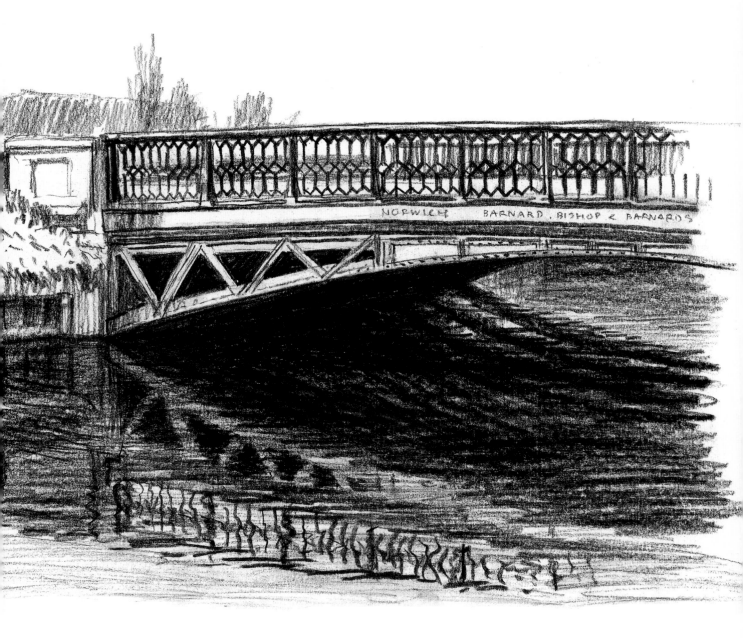

The dark underside of this bridge is much more in
evidence in the reflection than in the bridge itself

Chapter Seven

people

I have heard quite a number of artists saying that they can draw certain things but not others – landscape yes, people no. I think such self-imposed criticism is due to the fact that a subject such as a tree can be interpreted in a great variety of ways while still being immediately recognisable. Even when a very young child draws a tree, it can be recognised for what it is.

Likewise, a child can make a drawing of the human form that is totally incorrect anatomically, but will still be identifiable. Often such drawings are highly amusing, what they lack in skill, they make up for in simple honesty. Indeed, artists have long tried to recapture this childlike quality, and some have high reputations based on such an approach. But for students, the human face or figure is a demanding subject, and such is its subtlety that we are quick to spot shortcomings in a portrait, whether it is our own work or that of another artist. Therefore, we probably set higher standards for portrait and life drawings than for any other subjects. Perhaps the best way to approach a portrait is by being indifferent to the result. I mean that you must not expect the 'likeness' to be what you think it ought to be. If we can avoid being over-sensitive, a portrait can be tackled as if it were a bowl of fruit or a landscape.

A drawing made very quickly at a chance moment. (A raised arm will soon get tired)

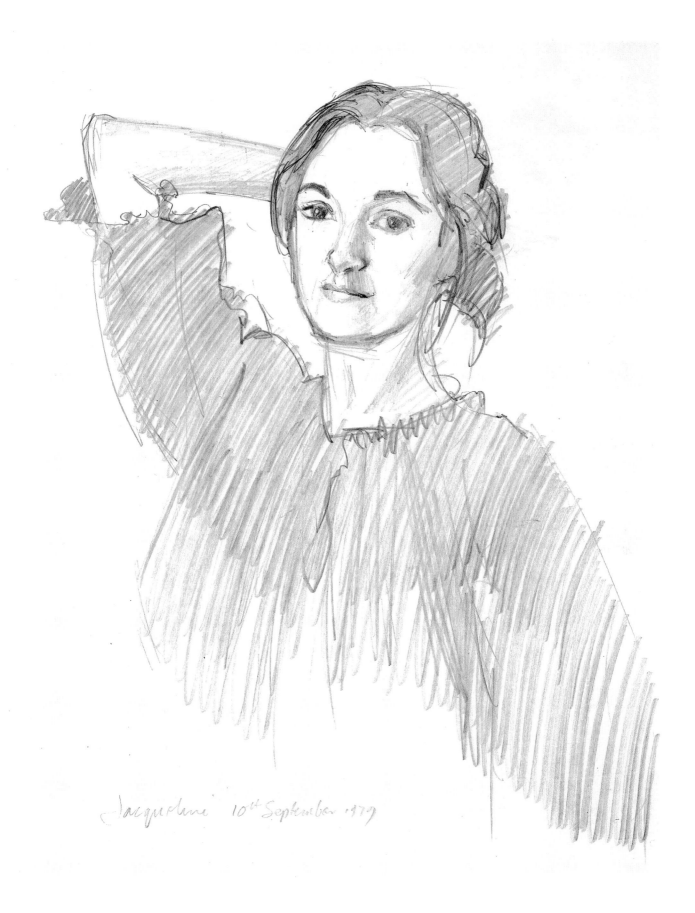

Jacqueline 10th September 1979

A drawing made when I was a student, worked with a fine steel nib, using diluted ink. I was particularly concerned with the boundaries and planes in this study

White conté pencil on dark-grey paper (right)

A portrait head drawn with pen and ink

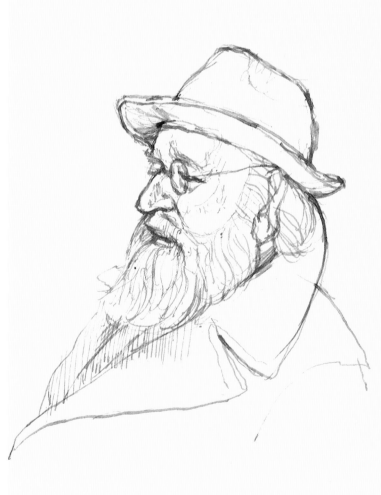

One of several studies I made of this gentleman. Collar, beard and hat all fused with the actual head.
Pen and thinned ink

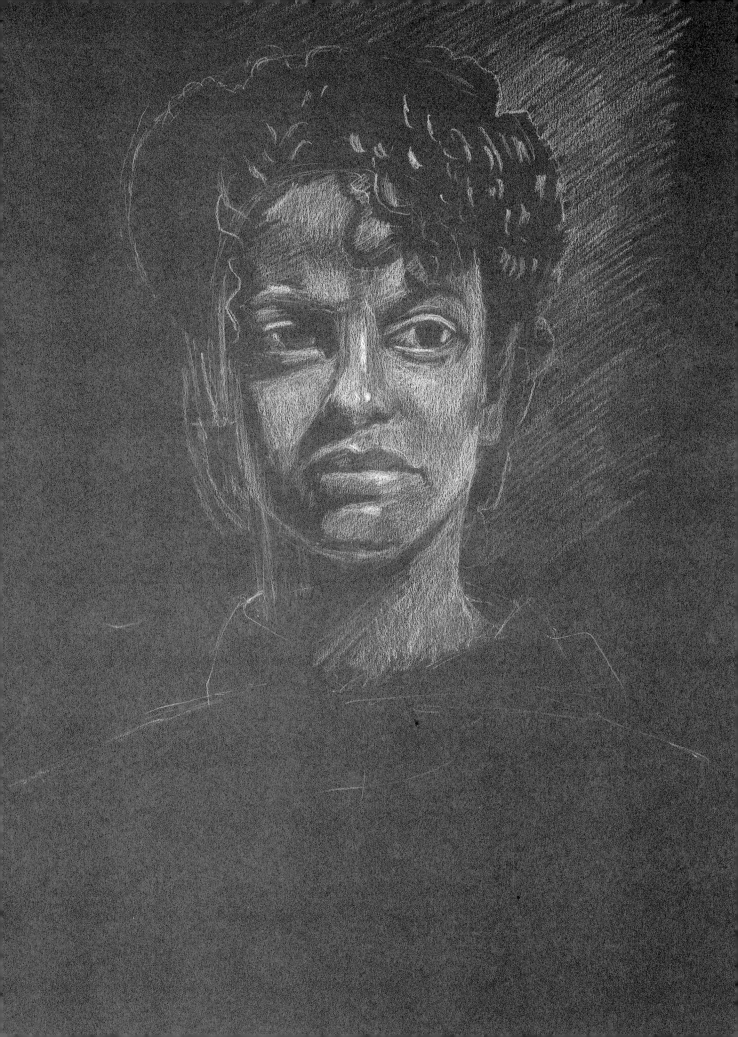

lesson 22 # Self-portraits

There is one model who is always on time and who never complains while the artist is still working. The artist! A self-portrait is a very good place to begin, incorporating many of the basic skills. Of course, it does have limitations, for the drawing and viewing positions have to unite in one, but it is perfectly possible to get used to this.

Use a large mirror, preferably flat on a wall. The frame or edge will not be involved. Either stand at an easel or sit on a stool at an easel. If you are right-handed, place the easel immediately to the right of the mirror and face the drawing board; if left-handed, place it to the left. This is to keep the drawing hand from crossing the reflection. Your range should be such that you can reach the paper easily with your arm extended. While facing the drawing board, turn your eyes back to the mirror. You will now have a three-quarter view of your head with your eyes turned. In this position you will not have to move your head at all when drawing, and in order to observe yourself you will only have to move your eyes back to the mirror. (If you wear bifocal glasses, you may find it easier to place your drawing board lower so that you look through the lower half of the lens, thus avoiding the irritating necessity of tilting your head up each time to focus on your drawing.)

Try to arrange the lighting so that more light reaches one side of your face than the other. A north light will be the most constant, or you can use a suitable electric-light source. Try to arrange a simple, plain background behind your head. It might itself have light variation and could, for example, be darker on the side where the head is light, and lighter where the head is dark. Mark the arrangement so that it is possible to get everything, including yourself, back to exactly the same position. It will probably be necessary to make some marks on the background wall to align your head.

When any model first sits they are invariably wide awake and alert, and stay beautifully upright. After a time they relax and slump a bit. This will also be true of the self-portrait, so consciously relax your position a little before you start.

For a first drawing I suggest you use a 2B pencil on white A3 cartridge paper. Before putting any mark on the paper, try to visualise quite where and over what area the drawing will take place. Begin by plotting where things are and considering your

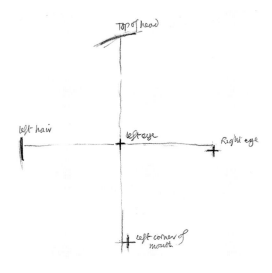

Step 1: The first thoughts and marks towards a self-portrait

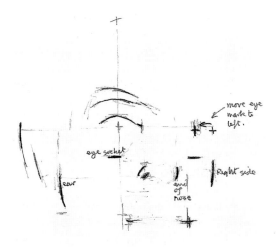

Step 2: The marks here are not part of the drawing, rather an attempt to find out how these parts relate to one another. Try to hold back from making definite decisions at this stage

proportions. Throughout this exercise, I will refer to left and right as seen in the reflection and therefore in the drawing.

Step 1

Mark the centre of the left-hand eye. Draw a faint line down from this to near the corner of the mouth. Draw another faint line to the right from the left-hand eye. Note that one eye might be lower than the other. Again starting at the left-hand eye, find the top of the head. Since I am quite bald, I am considering my skull itself, but it could be the hair. Now consider (a) eye to top of head, (b) eye to the very left of head (hair this time!), (c) eye to right eye, and (d) eye to corner of mouth. In my case, they are not far off being equal. This is good enough for the moment.

Step 2

Now consider the whole of the eye, the eyebrow, and the bridge of the nose. Drop a line from the corner of the eye towards the nostril. From that line, move left to the front of the ear. This space makes up the cheek. Consider the space from the nostril to the end of the nose, then from the end of the nose to the right-hand cheek. Not as much is seen of the right-hand cheek as the left. The nose is not in the middle of the face. This is where what the brain understands and the eye sees come into conflict. Do not let the nose drift back into the middle of the face, which is a very common fault. The darker area beneath the eye defines the eye socket. Place your finger across your face so that the top lines up with the edge of your eye socket. The lower part of your fingertip will press into your nostril. In other words, the nose is not as long as you might think. Rather than treating it as a long isolated blob with two air-holes at the end, think of the shape as related to the cheek, and consider its length in relation to the eye socket and to its distance from the mouth. Think collectively of the eye, nostril, mouth and chin – they have to develop together.

Step 3

The mouth has an upper and lower lip. Although the overall colour may vary, there is not usually a strong tonal change. Do not over-emphasise the outline, and try not to let the model use facial

cosmetics. Where does the bottom of the left ear come in relation to the corner of the mouth? Consider where the top of the left ear lines up with the right. I have drawn these first stages without my usual glasses, in order to show the head more clearly. However, if worn, spectacles should be built into all the dimensional considerations. They usefully sub-divide areas and become just as much a part of the head as any other feature. Do not try to finish any one part, but work around the whole head, confirming and modifying all the relationships. If possible, leave all the guidelines and checking lines. I know it may feel 'wrong' to have them on a face, but they will help keep your thoughts in check right up to the point when you think this particular drawing has said enough. Later, when more drawings have been made, you will find that some of these marks and lines will not be necessary; they will simply become thoughts.

Step 3: The framework advances further but still nothing is totally decided

Step 4

When drawing a head go down as far as the neckline. A collar running round the back of the neck is most useful to indicate that the head is a solid. Though all our measurements were two-dimensional, we are – of course – using them to describe a three-dimensional mass. In the same way, the hair should be seen as patches lying one on top of another. Do not try to imitate each strand of hair as if it were spaghetti. In a drawing, the tone of the hair can be a problem, especially if it is very dark or very pale. There is no simple formula, but I would suggest playing down the actual tone, giving as much attention as possible to the overall shape, the wispy or dense qualities, and the change of light.

Below is a similar self-portrait, drawn forty years earlier than **Step 4** below. The different parts of the face and the points where planes changed direction were described with a pen. Then pencil shading was added, but without dominating the pen.

Step 4: Once reasonably sound proportions have been established, the different parts of the drawing can be developed in unison. If you find you have made mistakes at this stage, it is better to start another drawing from scratch

A self-portrait drawn more than forty years ago.
Pen and pencil

For a second portrait, try drawing a friend or member of your family (see my studies on pages 134-135).

Sybil Woods.
A three-quarter view such as this shows the relationships between features most clearly

Oliver Van Oss.
This study had to be completed in little more than an hour. Drawn on stiff mounting card on an easel.
Pencil with slight touches of white pencil

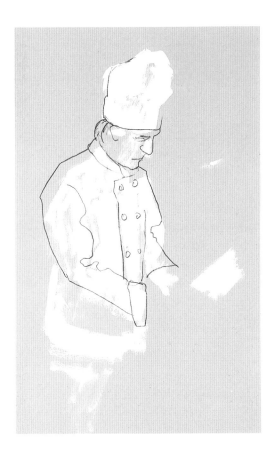

Frank Guppy disguised as a cook, drawn on half-tone grey sugar paper. The white gouache/poster paint was loosely applied first. While this was drying, I did a second version. Once dry, a 4B pencil was used to make a single boundary reconsidering the structure of the figure, without following the white shapes

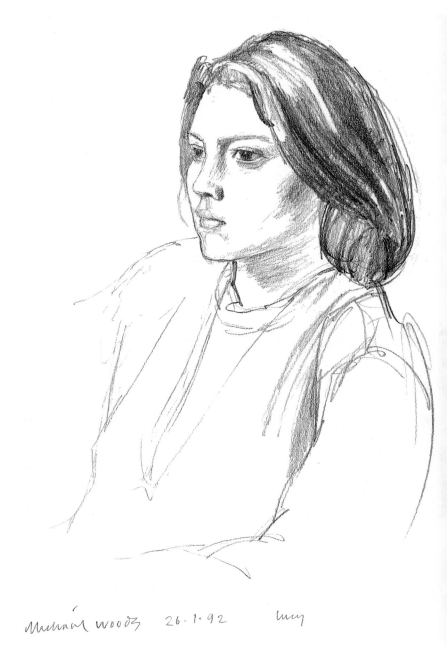

Michael Woods 26.1.92 lucy

Lucy Moss.
The sweep of the hair made a particularly nice shape

lesson 23 # Figures

Now draw a full-length portrait, or at least a good deal of the figure. If you wish to tackle a full-length self-portrait, you will need a large mirror such as that on a wardrobe door. I would suggest sitting down to work. The shapes in this drawing will be more varied, but you should set up much as you did in lesson 22. Drawing the whole figure presents far more problems than a simple study of a head. Clothes move and crease in different ways, so select something in plain, quiet colours which can be worn at each sitting for as long as the drawing takes. Choose clothes that have a clear shape, and keep their shape. Get the sitter to stand and sit down several times to see whether the clothes are suitable.

When drawing the whole figure, remember that it is not a study of a head with a body attached. The head is only part of the whole. In the following drawings I have made notes which you might find useful.

Oliver Woods.
Pen and pencil

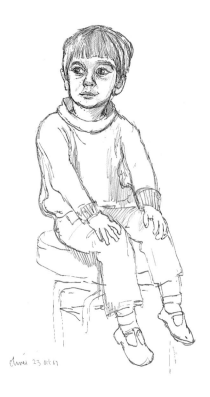

Mr Giffard in an art class at Bath (left). He was teaching someone else when I drew him in one or two minutes, using a brush and watercolour

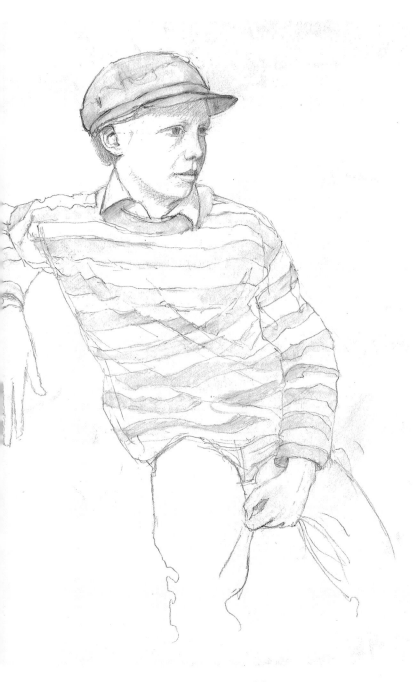

Frank Guppy sitting against a wall.
This sort of pose could easily be found on a beach.
White conté on black paper

Richard Wood stood in at short notice as a model in
a class. The hat was selected from a collection kept
for just such purposes. I used water-soluble pencil
because I wanted to indicate the stripes on his
T-shirt as subtly as possible

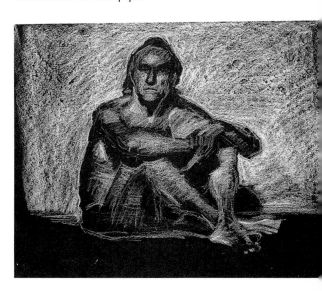

Chapter Eight

movement and activity

One of the most difficult things to cope with when studying drawing is the necessity of being continually prepared to react – to look, to think, to draw. One of the joys of studying at art college is that your whole attention can be focused on your work, even if for only a few short years. In later life, distractions will arise again, and it will be necessary to fight against these. Working in a class or a group, or even having a model to sit for you, will give you a set period in which to work, but the solitary artist has to make and organise time. Personally, I spend a lot of my time responding to landscape and the weather – the latter, in Britain, being totally unpredictable. But my ability to react almost immediately is crucial. At other times I will be working in my studio, but it is this variety that I seem to thrive on. Somehow, responding quickly is linked to drawing quickly.

Whatever the subject, it is possible, after completing a long, painstaking piece of work, to make a second version in a few moments which, though it may not do all that the former did, has a good deal more vitality. I cannot tell you how that's done. I guess

it's a combination of experience, choosing the right materials, looking for the right priorities, and having the bravado to put the marks down with a literalism which works. It is easier to describe it than to do it! Erasers won't help you work quickly, but pencil is good if you don't make too many corrections. Pen makes a clear, crisp mark while, if the circumstances are right, brush and ink can be very effective. Chalks are messy but bold.

Here is a collection of drawings made very quickly from a range of subjects, using a variety of materials. Each method was chosen because of its suitability at the time.

A waterfall cascading over rocks, drawn in water-soluble ink. As I drew I found that I wanted darker tones than were provided by the lines being wetted; so, rather than changing to watercolour, I spilt some ink into a mixing tray and made a stronger wash

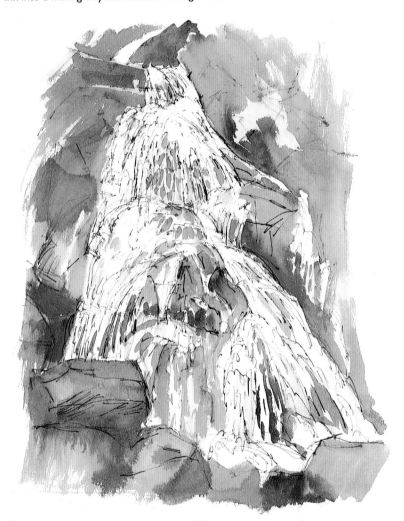

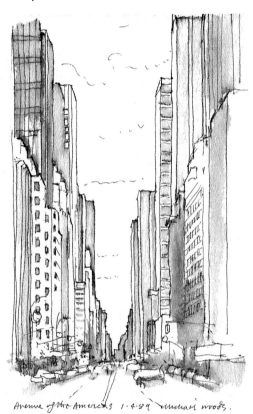

Avenue of the Americas 1·4·89 michael woods.

On a brief visit to New York I had to draw quickly, so this study was made with pen and spit! I always keep a field brush in my pocket

This power station was drawn from a train travelling at 100 mph. Some of the shapes have to be considered as they begin to appear, some as they arrive and some as they depart. I find pen and water-soluble ink and spit most suitable when I need to react quickly. A tone on the sky made the steam appear pale

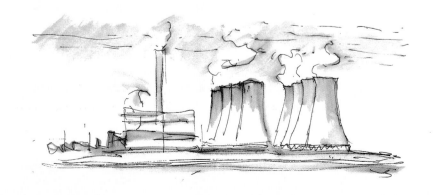

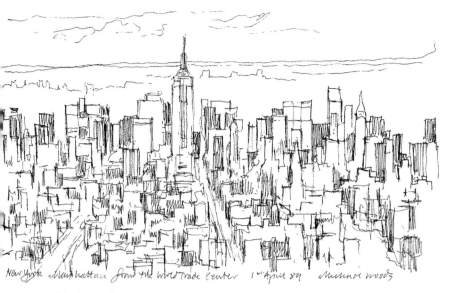

Manhattan from the World Trade Centre.
Pen

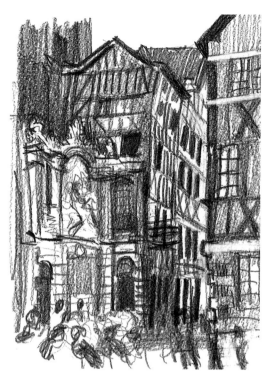

A jumble of people and buildings. Lots of rich darks
made me choose soft pencil, about 8B, for this brief
study in Rouen, France

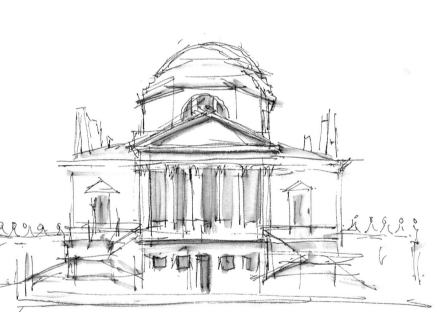

Chiswick House, London. This quick drawing was
made to demonstrate the proportions of the house
to one of my students. In many drawings the main
elements are more important than any amount of
detail

Being in the right place at the right time, and being
able to draw at such a time, is most satisfying.
Walking along the cliffs towards Cromer in Norfolk,
I found the light and shadow just right. This study
later became the basis for a much larger oil painting

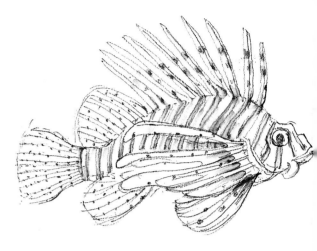

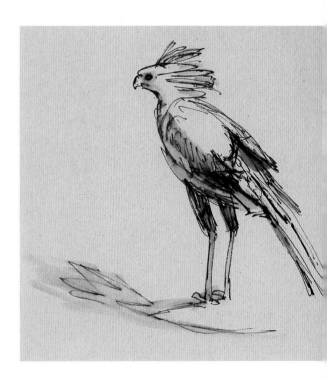

Study of birds in a wildlife park

When animals move they tend to repeat their movements. Fish in a large aquarium are splendid models, for they will swim past time and time again. The line here looks almost like pencil but, in fact, it was pen with a water-soluble cartridge which was just about to run out. Rough absorbent watercolour paper needed a lot of ink and so the line crumbled. A little wetting produced the few darker tones

Sweeping shapes can be echoed by sweeping lines. Marks were needed to suggest movement in this drawing of a strutting peacock

The shapes of birds and animals can be quite unexpected – even odd. It is good for the artist if only for a while, as this discourages preconceived ideas about what things look like. This bird is far from being a sweet little budgie

lesson 24 # Quick Drawings

Over a period of two weeks (possibly a holiday) make at least fourteen quick
drawings, each taking no more than five minutes. If nothing is drawn on one day,
two will have to be made on another. Set yourself a goal of at least one quick
drawing each day.

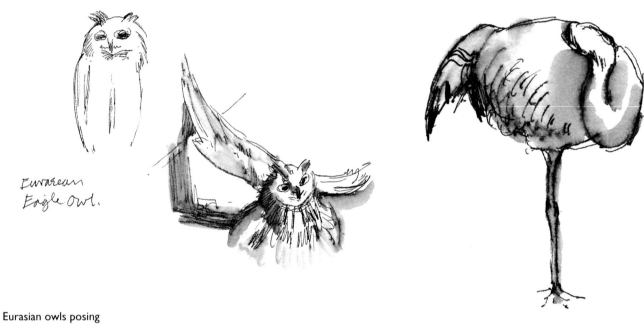

Eurasean
Eagle Owl.

Eurasian owls posing

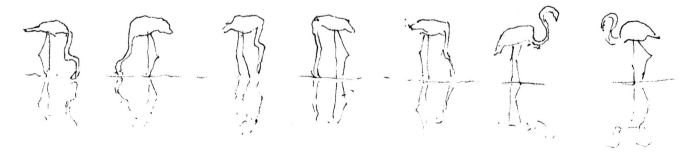

Flamingos in the Camargue

Chapter Nine

townscapes and landscapes

In contrast to the quick reactions and the brief drawing time required for some subjects, a townscape can often be worked at a more measured pace, being planned in advance, and perhaps taking some time to complete. To know that you can return to a subject on more than one occasion has quite a calming effect on the progress of a drawing, although if the subject involves light and shadow, a second visit may have be made at roughly the same time of day.

I knew Cow Hill in Norwich quite well, but one day I passed by and noticed the late-afternoon light. On another day, when the conditions were similar, I returned to draw. This time it was not just the subject but the way the sun was catching the lower houses, contrasting them with the church tower, that excited me.

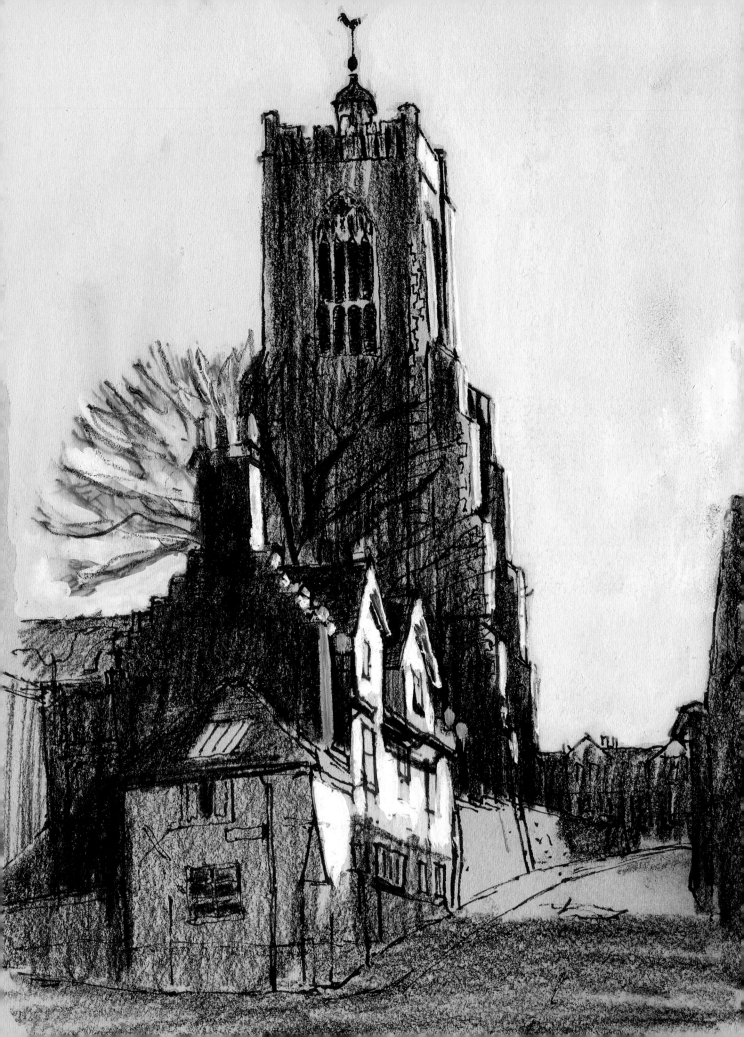

Number 7, Piazza di San Francesco, Florence.
Pen and sepia watercolour washes.
The façade of a building in Florence caught my
attention as I drove by. Happily I was able to return
a few days later, and I completed the study in three
sessions – a total of five or six hours. The
complicated projections were what attracted me.
This view of the building, looking upwards and set
against the sky, would only have been a problem had
I been facing directly into the sun

Cow Hill, Norwich (left).
Pen, black conté stick, white gouache, and some
watercolour for the pale sky and light areas of the
nearest house

Pen and ink

I was thrilled with the Manhattan skyline and this pen drawing was the first I made. Accuracy was, I felt, very important so, though it looks relatively simple, I took time to consider all the proportions and relative sizes of the buildings. A colour study which followed was much freer, and from a combination of both I developed several large oil paintings.

The beach house in South Carolina was drawn quickly, using a soft pencil, because I wanted to capture the dark patches created by the balconies, and the texture of the rails and steps that led down to the beach.

Pencil on watercolour paper. The textured nature of the NOT surface (see p. 25) lets the pencil break, and the light spots keep the surface alive

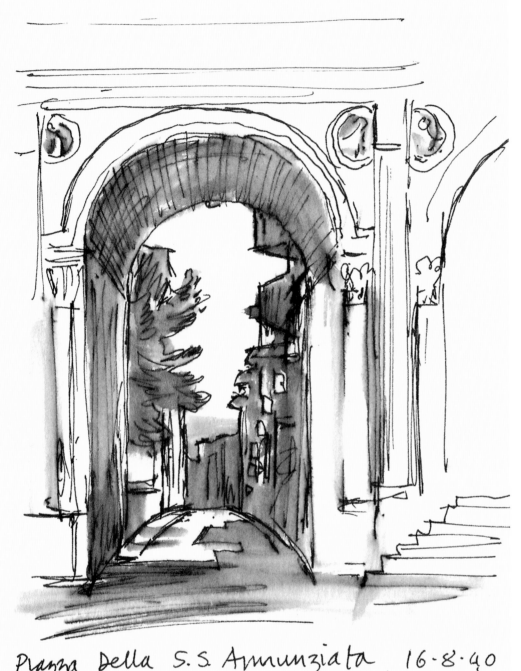

Piazza Della S.S Amunziata 16·8·40
michael woods

The view through the arch was another brief drawing, this
time using pen and a wetted ink wash. I noticed the arch-framed
view as I walked by, and the light and shadows. These sketches of
a road in Norwich give an idea of my thoughts when selecting a
subject and of how I set about working. Try to follow these
guidelines when you consider your own subject.

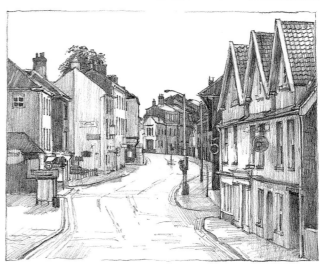

This road in Norwich was in my mind when considering a townscape subject.

Fig. **a** shows the broad arrangement I had in mind, not the scene as I started drawing.

Fig. **b** shows the general directions of the buildings. Immediately in front of me the street continues to fall; then, swinging to the right, it rises again before swinging left with a fork to the right. So, for many of the buildings, the view looks down to the ground line and up at the roof line. My horizon (dotted line) is just about halfway up my planned rectangle

In fig. **c** I considered the range of tones across the composition. The lamp post nearly in the centre was, at its base, dark against the pale path and road – yet higher up it was lighter than the buildings in shadow in the distance. Because no colour was to be used in this drawing, I had to take care not to lose the valuable thin light line. Pencil can be quite clumsy in such cases, for if it is used simply to define the edges and then to shade up to the

lines, the lines themselves will become absorbed in the darker tone, and too little of the light 'middle' may be left. Therefore care must be taken.

I started the actual drawing (fig. **d**) in the farthest distance, right in the middle. I then moved out to left and right, noting how the proportions fitted together. For the first half an hour I had no precise boundary drawn, though I knew roughly where it would come. Taking care not to smudge the pencil, I started the tonal shading from the top left, and more or less worked across to bottom right. As all the parts came together I returned to some areas more than once to strengthen the tones. I decided not to include a cloud that had invaded the sky – the shading necessary would have lessened the overall brightness and, therefore, the contrast with the darker buildings. On another occasion I think I would draw larger because, when well into the study, I found that many of the smaller elements were a bit fiddly to draw when so small. The size of the drawing is often not assessed until it is actually completed. This is why more than one study of any subject is so valuable

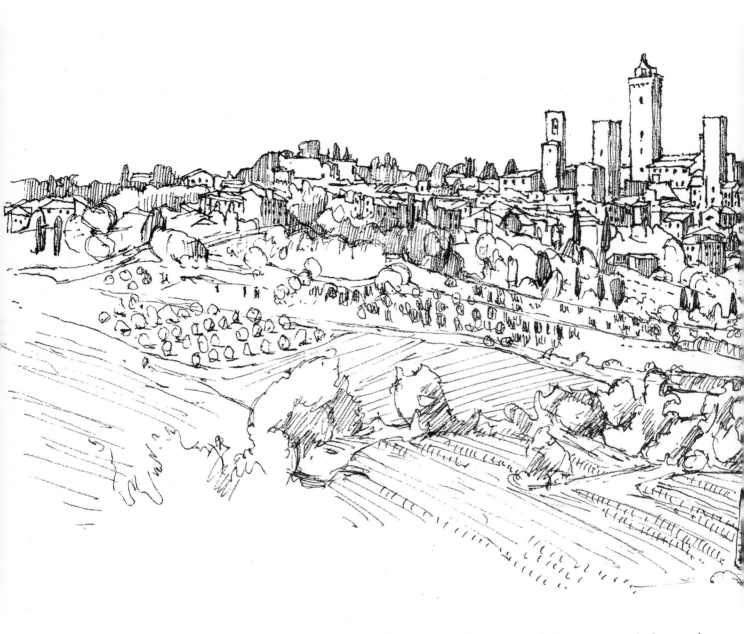

I had been to San Gimignano in Italy many years before, and when I had the opportunity to visit this enchanting hill town again I planned to draw it. Standing on the edge of the town I looked out to the fields and roads and, with reference to a map, tried to calculate where I might get a good view looking back at the town itself. Two attempts came to nothing – the land dropped away and buildings and trees blocked the view. But a third road rose up to provide just the aspect I had hoped for. This sort of problem does have to be overcome when drawing landscapes, for what you want to paint does not always coincide with what you can actually see.

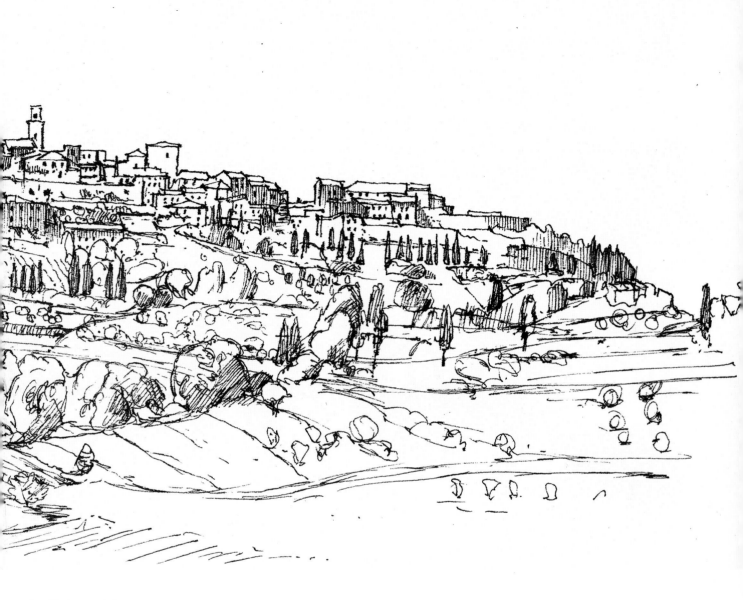

San Gimignano, Italy.
Pen

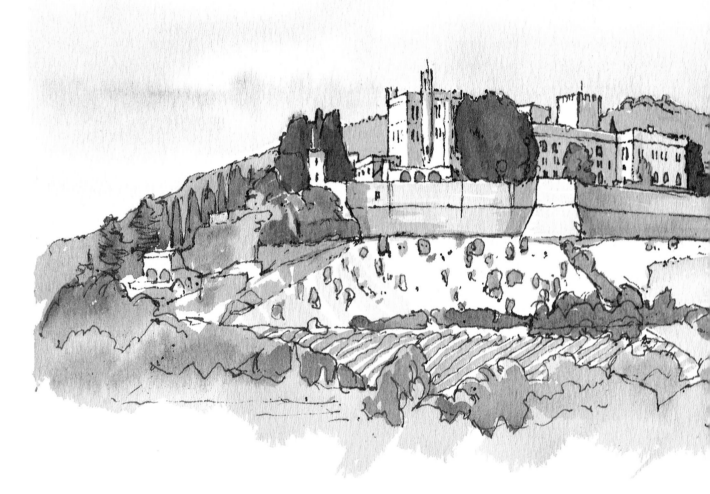

Castle Brolio in Italy makes an attractive subject, set in its Chianti landscape, but there were very few clearings where the group presented itself as a drawable composition.

Castle Brolio, Italy.
Pen and fixed ink and watercolour wash

Michael Woods 24.10.91

The sea defences at Happisburgh in Norfolk offer strong
shapes, and this drawing was made at low tide. Beach and sky were
not developed in this study but I did get to know the way the
defences were constructed.

Being out in the countryside on a summer's day brings to
mind all sorts of pleasant sensations: the smell of the earth and the
plants; the sound of animals grazing, of water falling over stones, of
the rustle of grasses and leaves; the warmth of the sun; and possibly

the pleasure of someone else's company. Yet, of course, none of those sensations can be put into a drawing. The artist has to use shapes, lines and tones to create a small rectangle where some of these qualities might be implied. It is useful to have access to a particular area that one knows well, and for which one has enthusiasm. To understand the shapes and colours, the light direction at different times of day, and the changes of the seasons, must help when it comes to selecting a site in which to draw.

Happisburgh, Norfolk.
A brush pen (a proprietary brand) on watercolour paper

a This drawing shows the basic thoughts concerning the main cluster of trees between the curve of the skyline and the foreground

b The light coming from the right creates a sequence of light against dark, dark against light

c The thoughts shown here involve areas of trees contrasting with the lines of the hedgerows

In the landscape shown opposite I returned to a favourite area of mine, the Tas Valley in Norfolk. It is very gentle, not at all dramatic, and yet the groups of trees and the patterns of fields and lanes are full of good visual material. Everything is on quite a small scale so nothing is that far away – indeed, the whole area is only a few miles square. The cluster of trees lying between the curve of the skyline and the curve of the foreground formed the basic core of this drawing (fig. **a**), helping to hold all the parts together. The weather was bright but showery, and so cloud shapes come into the drawing. Those shapes together with the trees produced a whole series of volumes, light on one side and dark on the other. The light comes from the right, and running across the area is a sequence of light against dark, dark against light (fig. **b**). I knew that it would be important to preserve as much white paper as possible in some of the main light or sunlit areas. In fact, by making the most of the grey clouds in the distance, I was able to show the effect of light on the middle distance.

Another consideration involved the trees which contrast with the lines of the hedgerows (fig. **c**). It is quite obvious that not all the trees are the same size, but together they convey a sense of space as the valley descends, as well as the distance from the floor of the valley upwards to the church tower on the skyline. The lines of the fields passing behind the trees also make it easier to see the volume and position of the trees. In addition, these lines have the effect of locking the composition onto the edges of the picture rectangle.

Because I wanted to work in strong tonal contrasts right from the start, I chose a charcoal pencil. The drawing (fig. **d**) took about an hour and, in that time, I had to sharpen my pencil four or five times. I started with the main group of trees in the centre and worked outwards in all directions, returning to each area many times to develop both its shape and tonal values. Of course, the clouds kept passing and about forty minutes into the drawing a particular group began to move into my view. Starting before they arrived I was able to develop enough of them before they had passed out of view. The grazing sheep were then drawn, and I took care to get the overall size right, for, in this way, the space of the field is suggested. I thought the rain was going to arrive any minute, in fact it never did, but it kept me working fast. Sometimes this is no bad thing in a landscape, for it prevents unnecessary detail and keeps one's attention on the most important aspects.

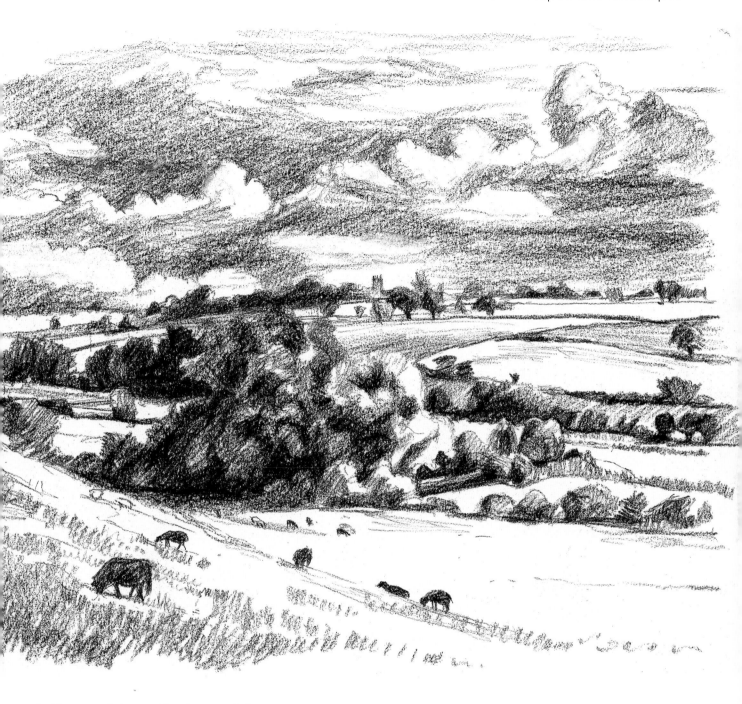

d The accumulative considerations seen in figs
a – c come together to produce the final landscape

lesson 25 # Selecting Your Own Subject

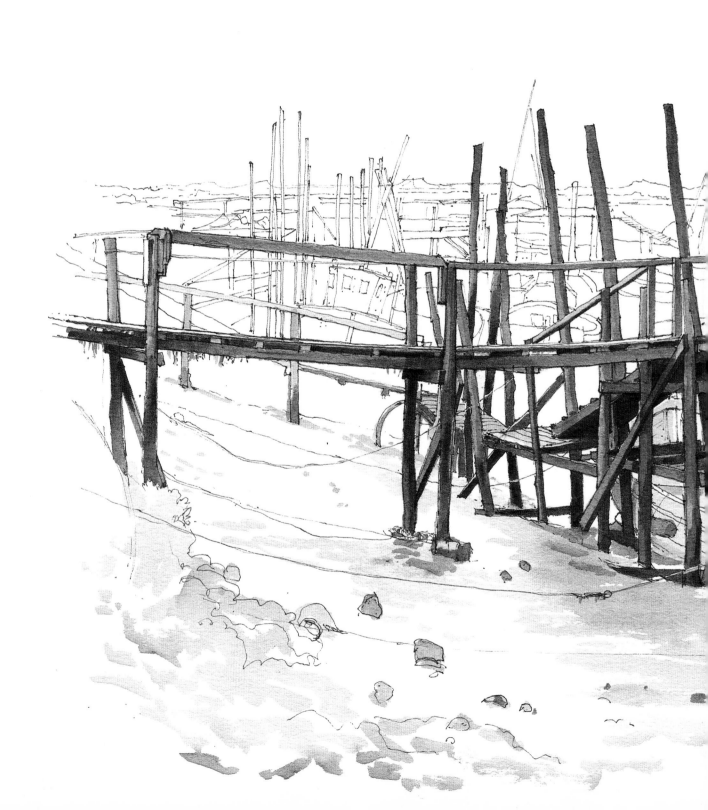

For the final lesson, find a town subject which you can reach easily and return to on as many occasions as your drawing demands. Alternatively, select a landscape composition. Many subjects, of course, may be a fusion of both.

Postscript

If you have got this far and attempted all twenty-five lessons, you will certainly know what drawing can be about. The ideas I have offered are not meant to be a set of rules, but I hope they will set you thinking, and provide you with many hours of happy drawing.

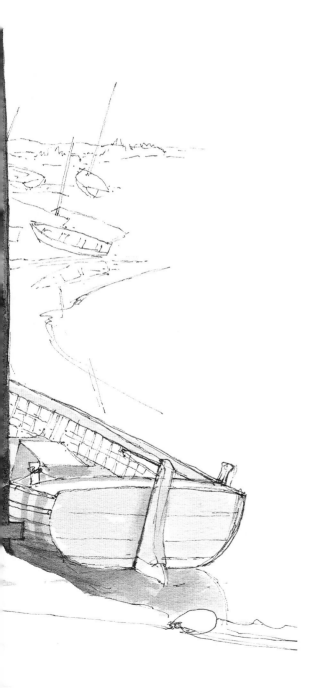

Landing stage at Morston, Norfolk

Index

Illustrations are italicized

741.2 WOO
Woods, Michael, 1933-
The complete drawing course

WARREN TOWNSHIP LIBRARY
42 MOUNTAIN BLVD.
WARREN, N.J. 07059

BAKER & TAYLOR